Recycled Realities

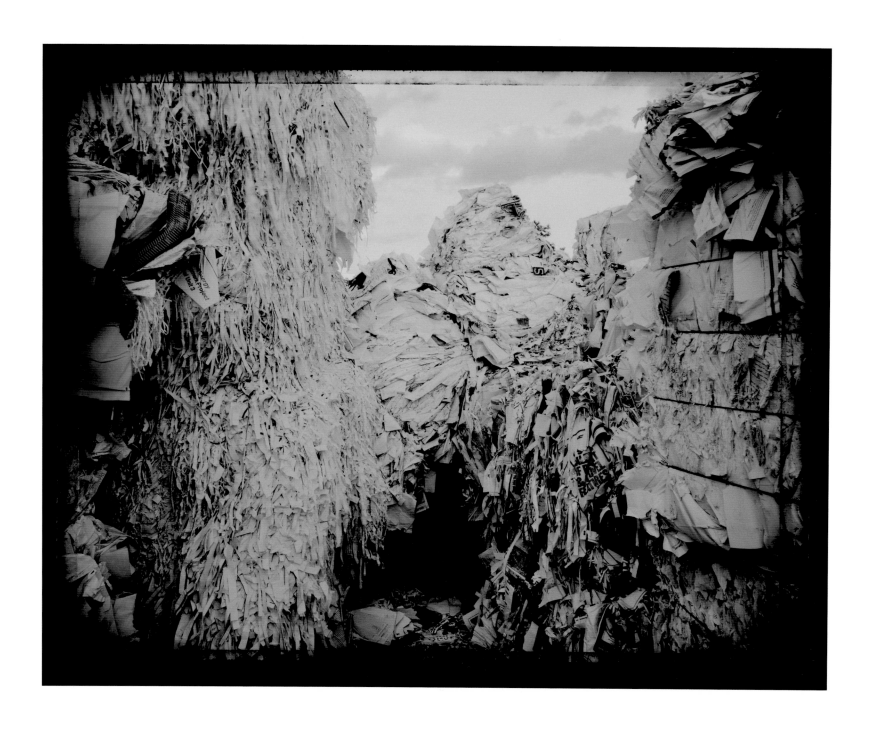

Recycled Realities John Willis and Tom Young

with a conclusion by Martha A. Sandweiss

Center for American Places

Santa Fe, New Mexico, and Staunton, Virginia

in association with Columbia College Chicago

Center Books on American Places
George F. Thompson, series founder and director

PUBLISHER'S NOTES: *Recycled Realities* is the fifth volume in the series *Center Books on American Places*, George F. Thompson, series founder and director. The book was brought to publication in an edition of 2,000 clothbound copies with the generous support of Lillian Farber, Charles Housen, Thomas Newton, Jeanne and Richard S. Press, David Willis, Columbia College Chicago, and the Friends of the Center for American Places, for which the publisher is most grateful. At Columbia College Chicago, thanks also to Dr. Warrick Carter, President; Steven Kapelke, Provost; Leonard Lehrer, Dean of the School of Fine and Performing Arts; and Michael DeSalle, Chief Financial Officer. For more information about the Center for American Places and the publication of *Recycled Realities*, please see page 72.

©2006 Center for American Places
Photographs © 2006 John Willis (square images) and Tom Young (rectangular images)
Published 2006. First edition.
Printed in Iceland on acid-free paper.

The Center for American Places, Inc.
P.O. Box 23225
Santa Fe, New Mexico 87502, U.S.A.
www.americanplaces.org

Distributed by the University of Chicago Press
www.press.uchicago.edu

9 8 7 6 5 4 3 2 1

Library of Congress Cataloging-in-Publication Data is available from the publisher upon request.

ISBN 1-930066-48-1

Contents

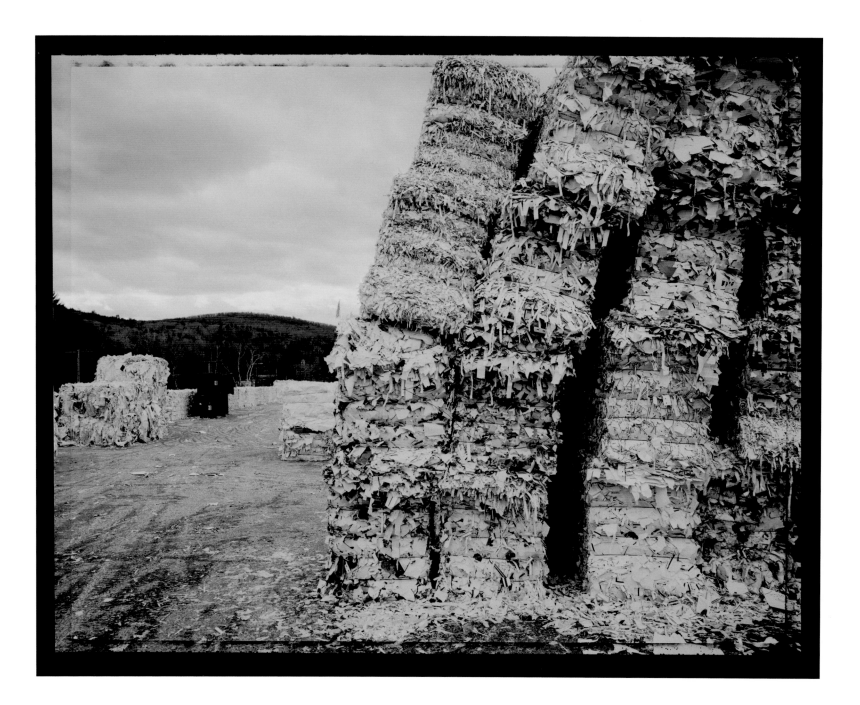

Introduction: Where We Live

John Willis and Tom Young

NOT FAR FROM WHERE WE LIVE in the mountains of New England, there is a well-traveled road that winds its way through the picturesque scenery. Around a sharp bend in the road, there is a paper mill nestled down by a river, in an otherwise pristine vista of forested mountains. Two smokestacks reach upward far beyond the treetops. Day and night they bellow clouds of steam into a big sky. Below the stacks, an expanse of soft white forms made from bundled scraps of paper construct an environment that appears at once alien and strangely akin to the surrounding landscape. As the winds kick up, sending shreds of paper whirling in the air like small cyclones, the mill workers maneuver their forklifts throughout the platform. They continuously change the landscape of bales by removing certain ones to add to the paper mix, while always replacing them with newly arrived bales.

This new landscape of virgin and recycled trees is one of aesthetic and philosophical contradiction for us: such a harsh industrial landscape is invasive upon nature, but it also holds the promise of creative re-use of limited resources. Mountains of baled paper scraps wait to be turned back into products that will re-enter the marketplace, scrap paper that carries images drawn from every conceivable use of the printed page in our culture. We are interested in this transformation from a living forest to a constructed representation of human activity.

In exploring the seemingly random placement of paper, the variety of images amazed us on formal and conceptual terms. In searching for visual and communicative breadth in our image-making, we sifted through this landscape of paper mountains, watching carefully for photographs to present themselves. Juxtapositions of imagery revealed individual and cultural voices of the past, whispering, calling out, and validating memory. In ways both disturbing and intriguing, the discarded paper carried images and text from popular culture, formed into a new topography with lingering evidence of its past existence.

It remains unclear to us if what we found was only random and about chance, or if the images reflect also a collaboration with the workers who would often move things around and highlight particular images within the stacks. Either way, our photographs attempt to make sense of this seemingly complex and chaotic world of recycled realities in front of our eyes and cameras.

In our process of photographing at this mill, we returned weekly over a three-and-a-half-year period. This enabled us to feel at home within the strange landscape, connecting the place to our own personal histories. While photographing at this site we became aware of the temporary nature of this landscape. It is a repository about to be reconditioned into other consumer products. The images of people and culture buried in the stacks of paper called out to us, and seemed to beg us to look within at our transitory existence and the fragile natural world that surrounds this site. This connection of self to the world is one of the most comfortable, most familiar, and most grounding experiences we can have.

Recycled Realities

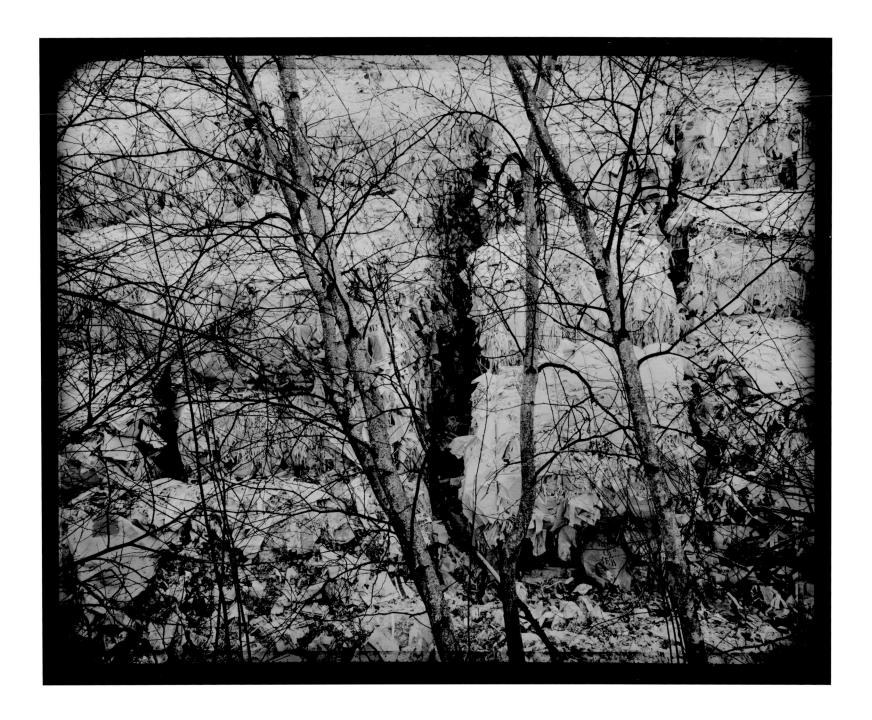

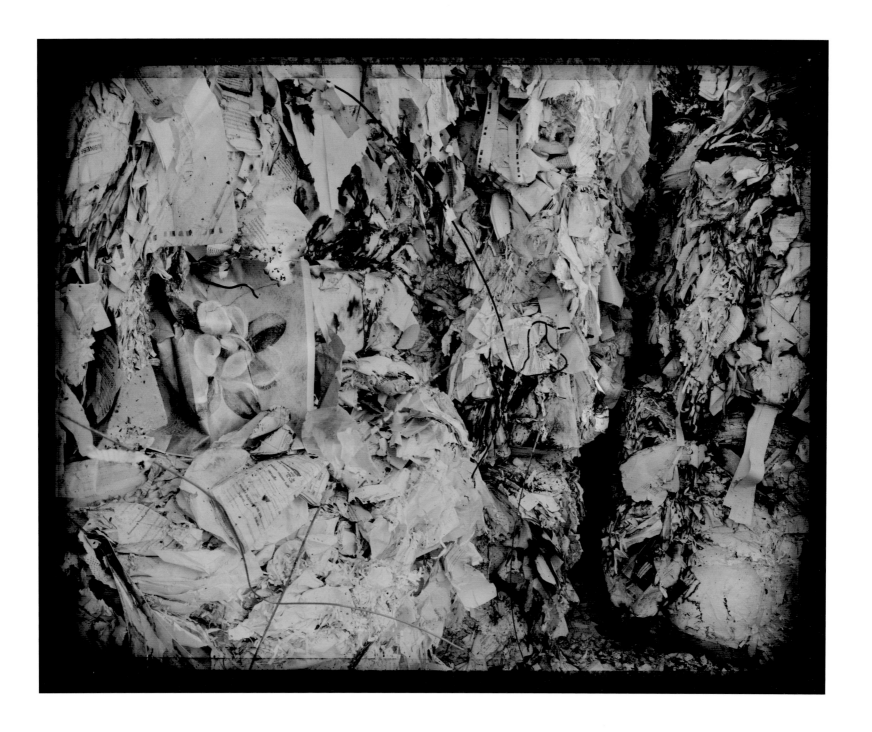

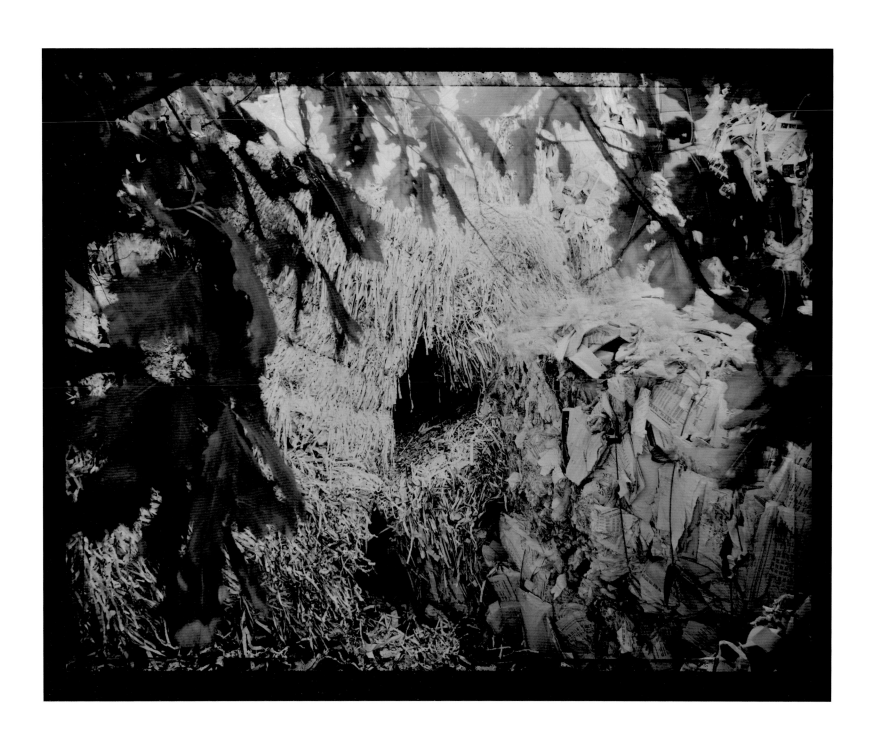

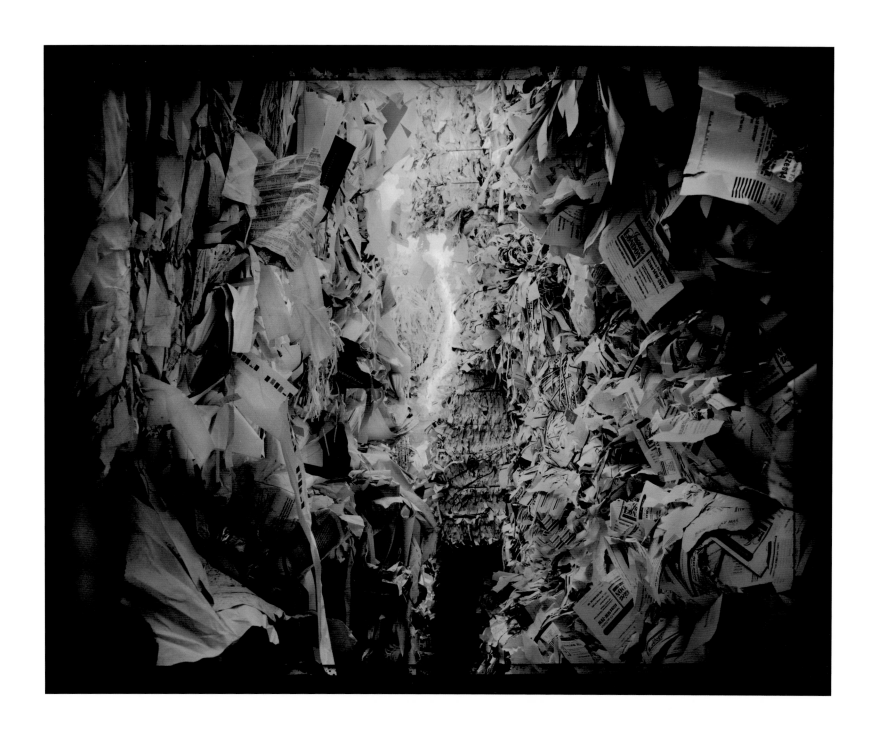

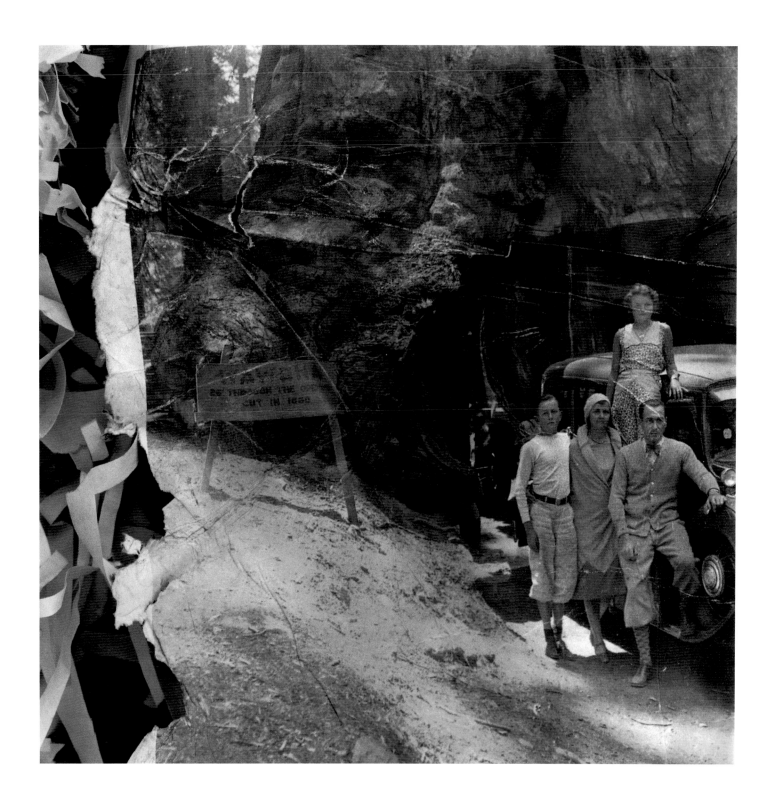

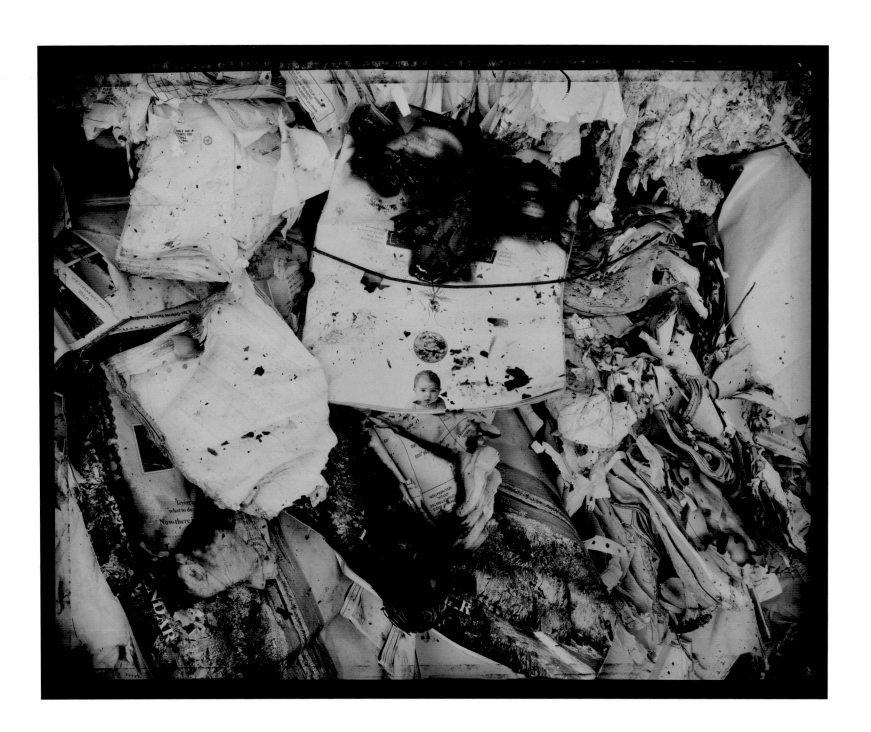

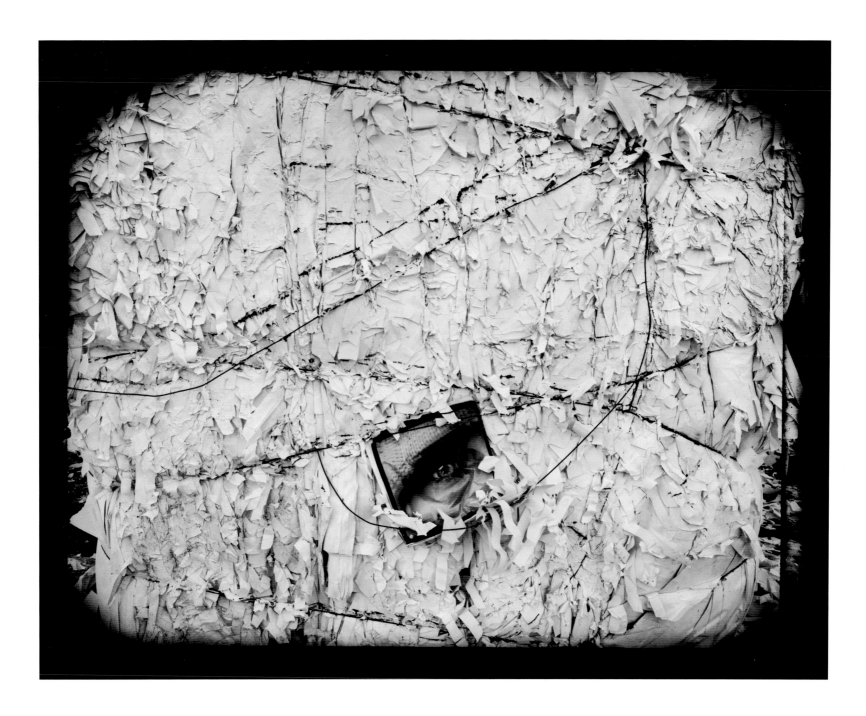

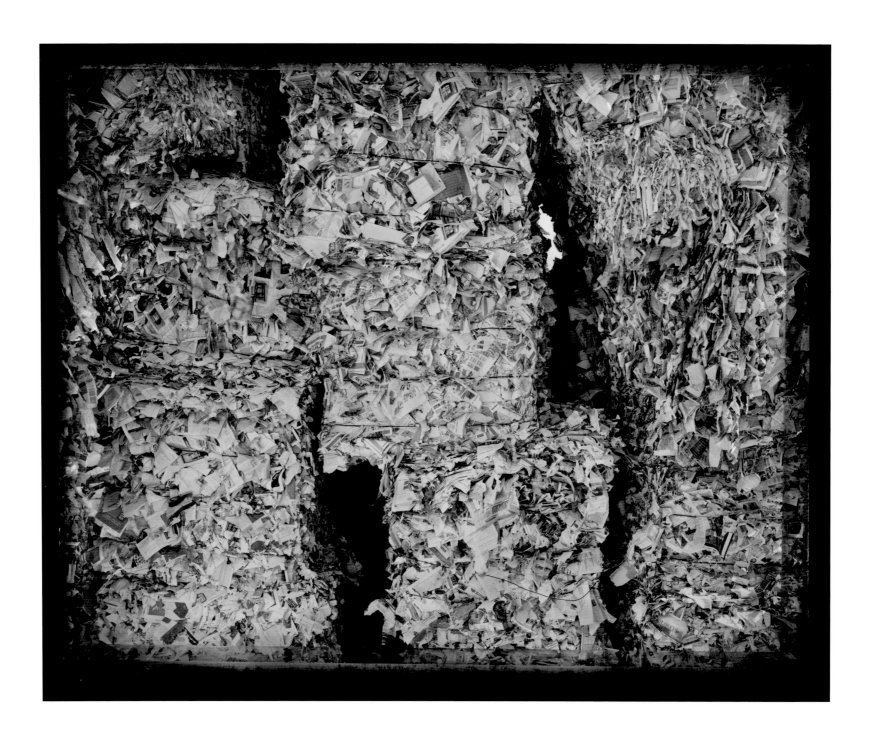

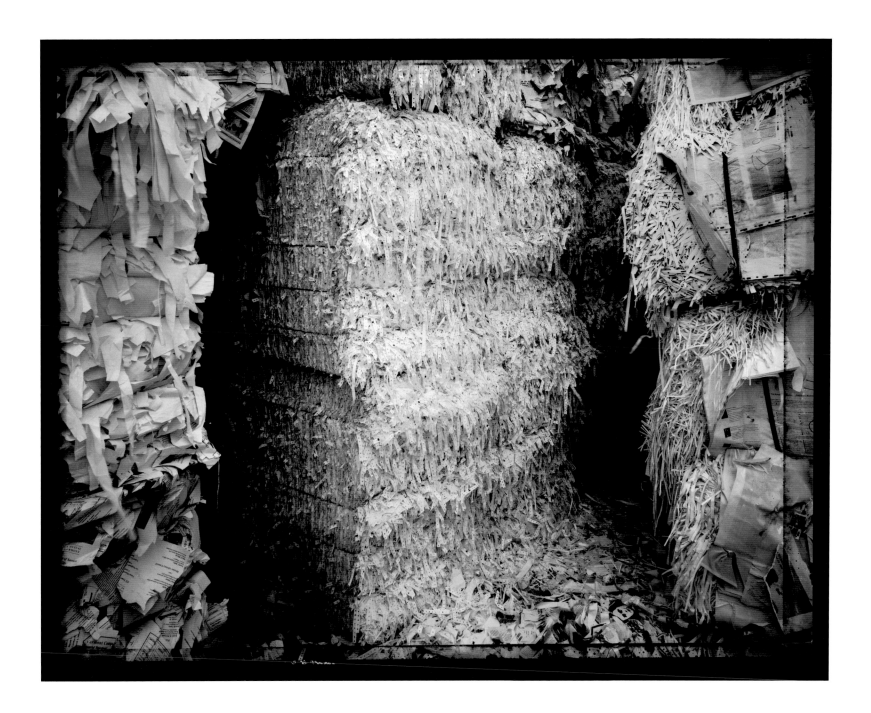

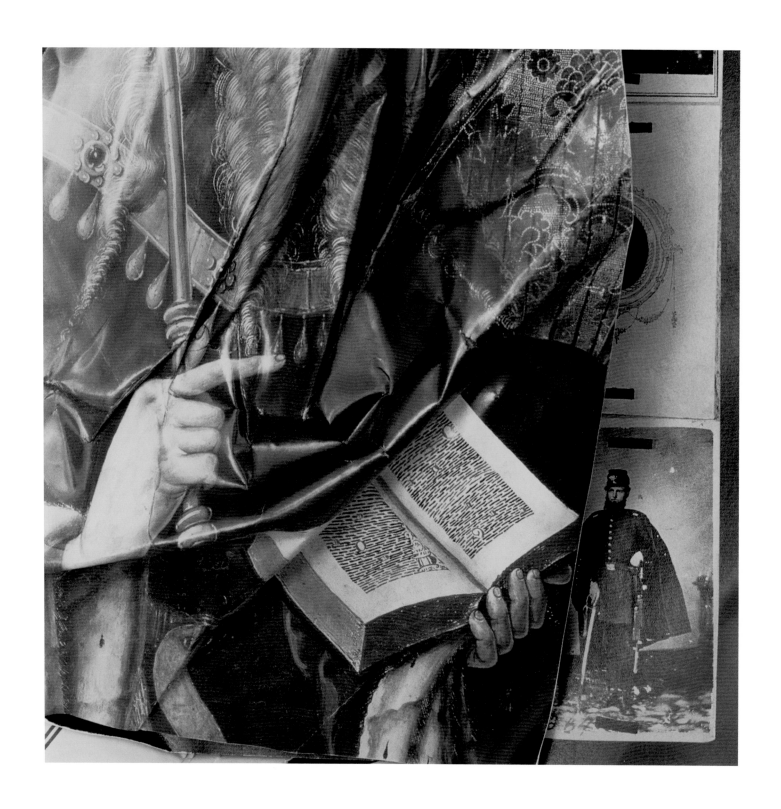

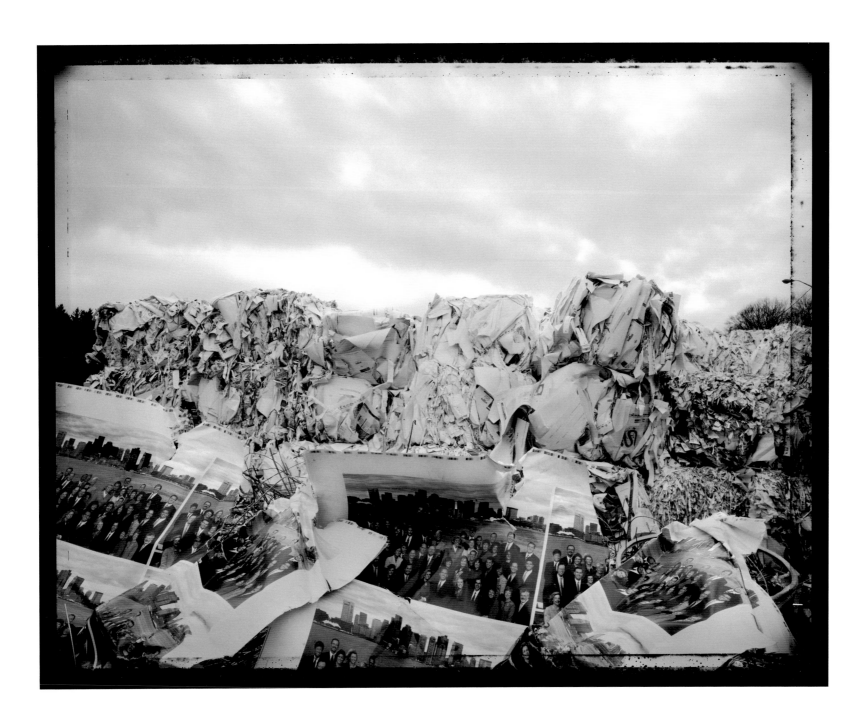

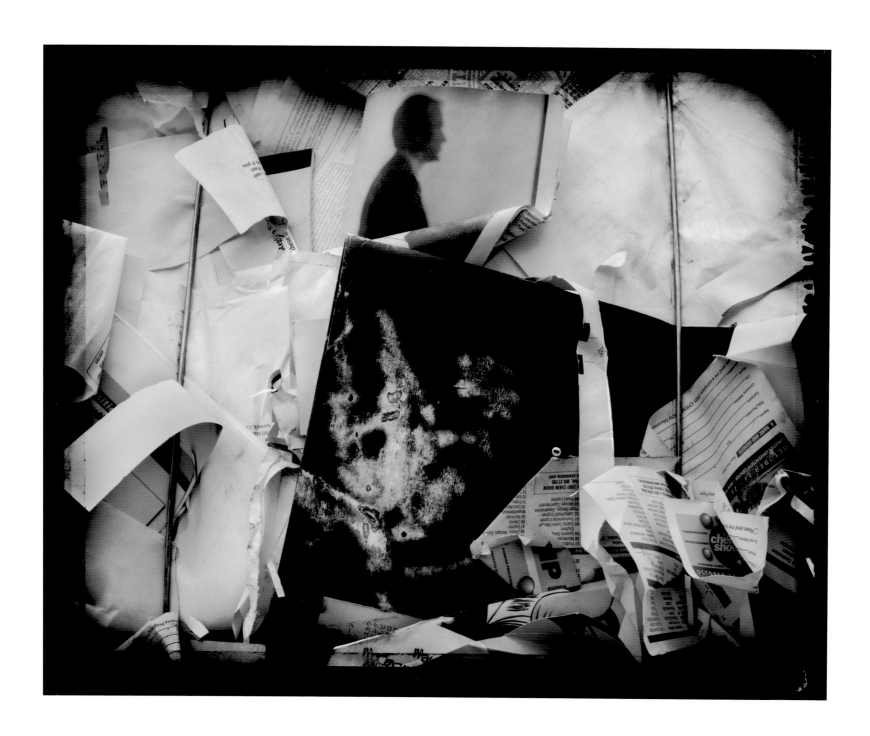

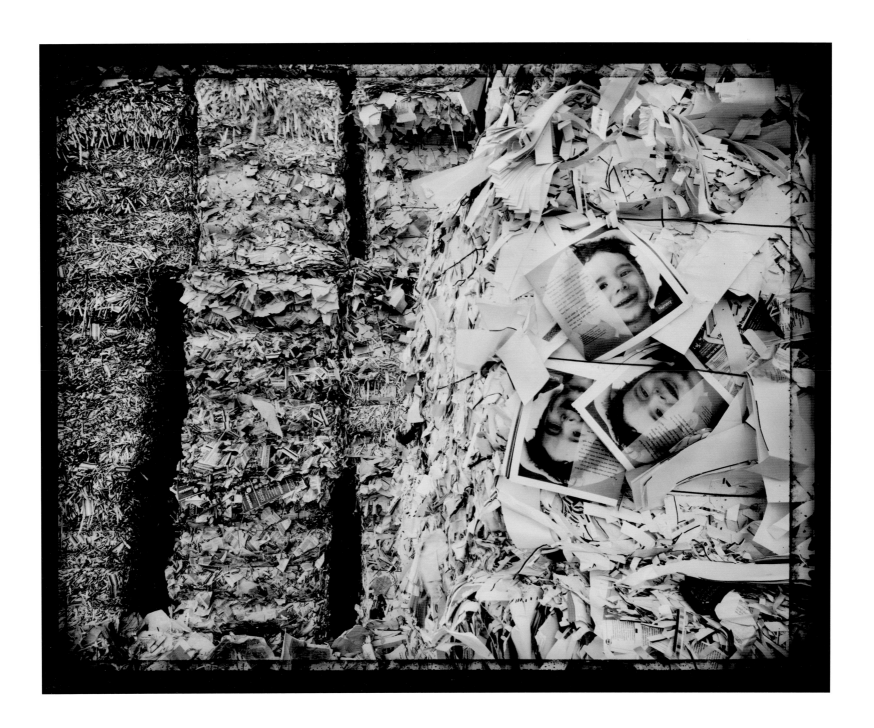

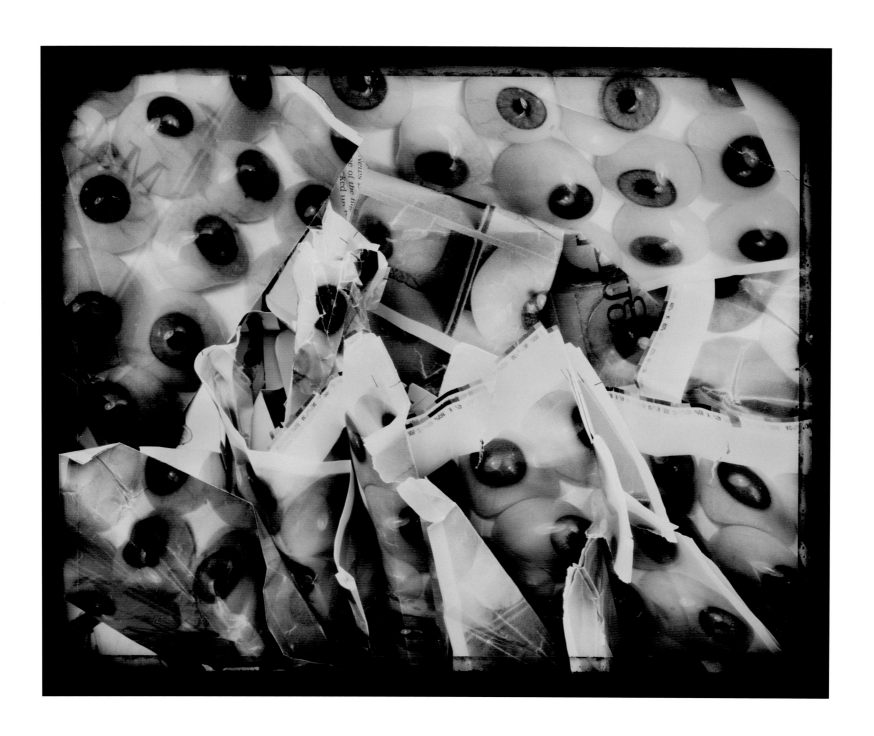

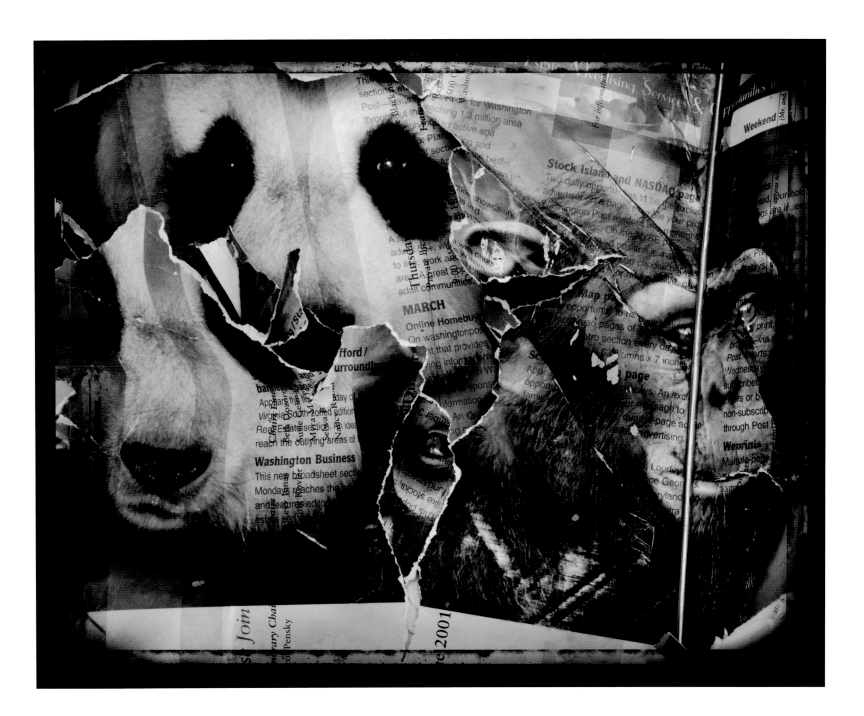

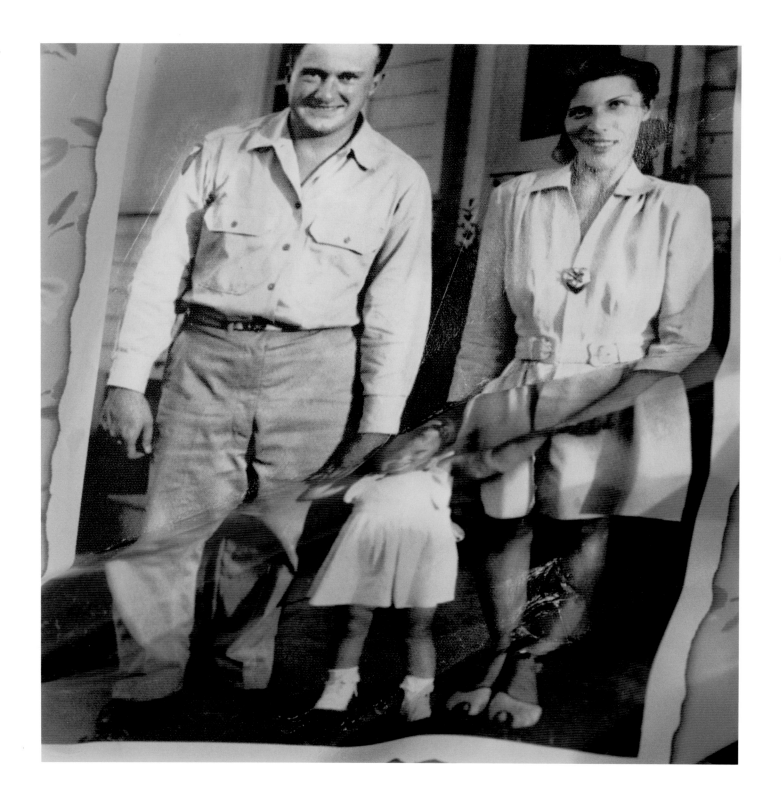

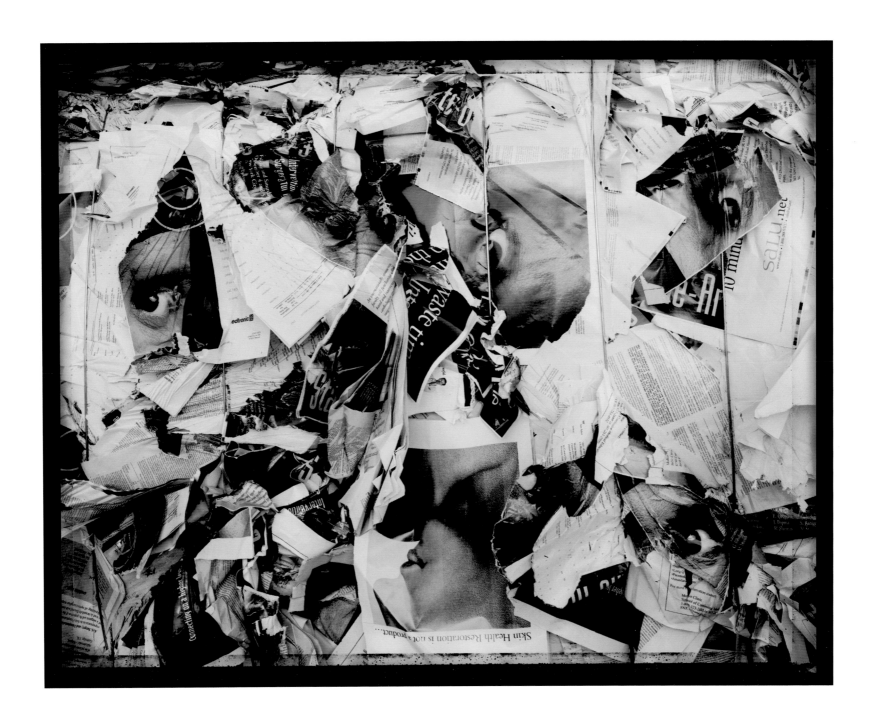

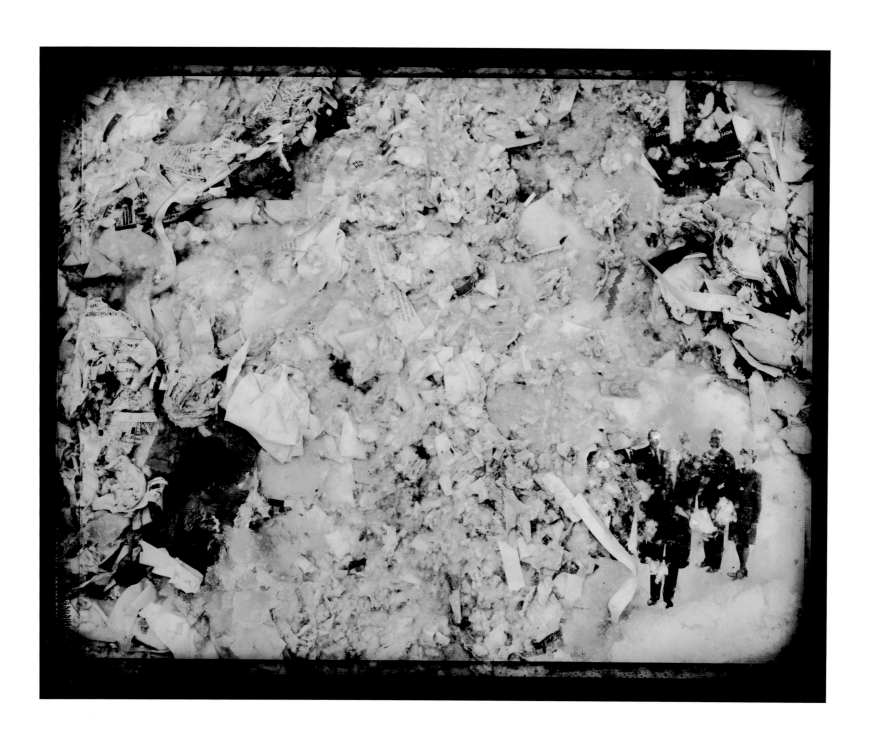

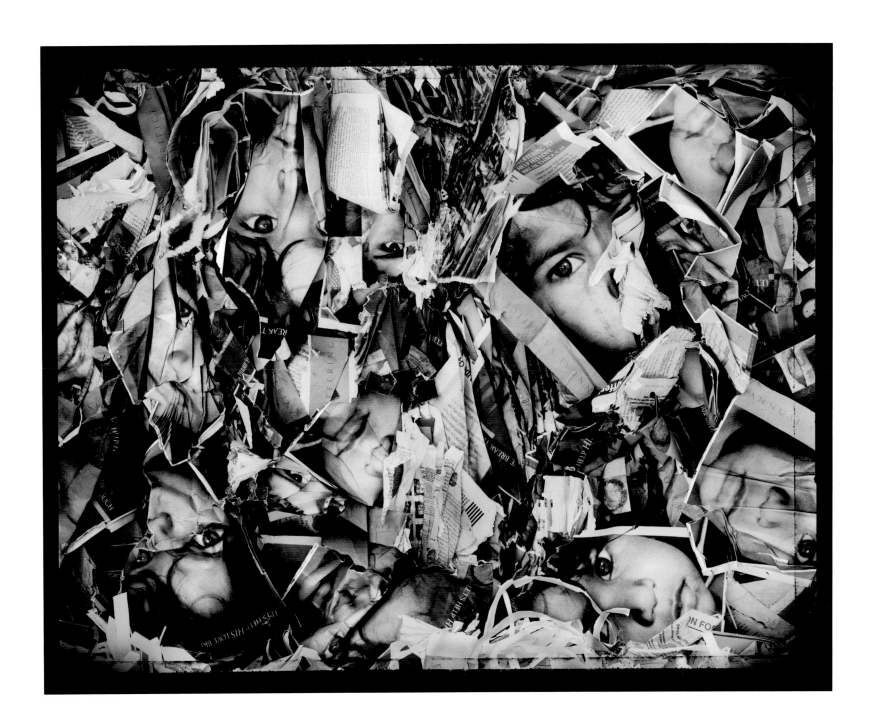

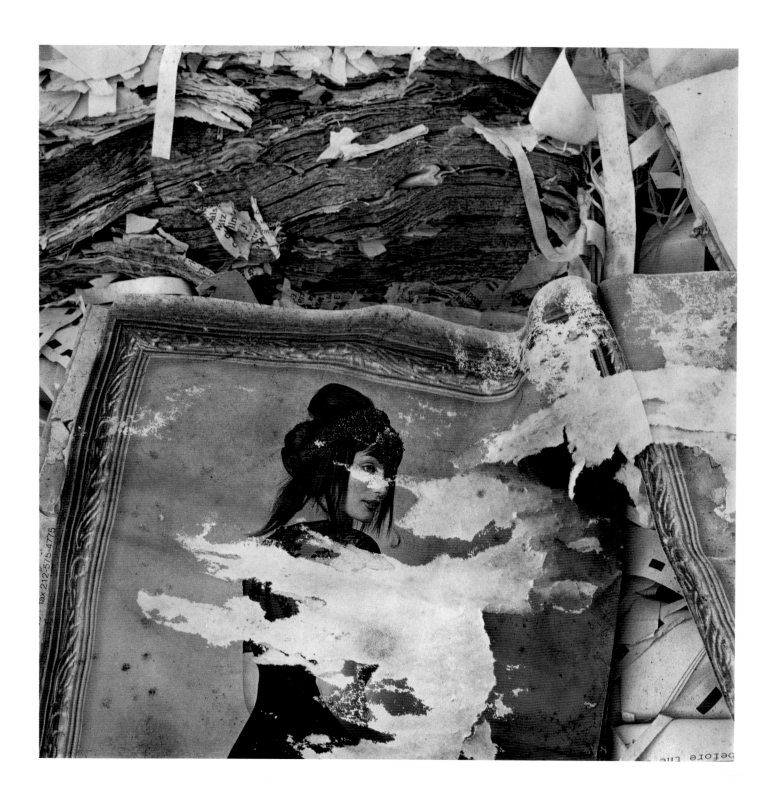

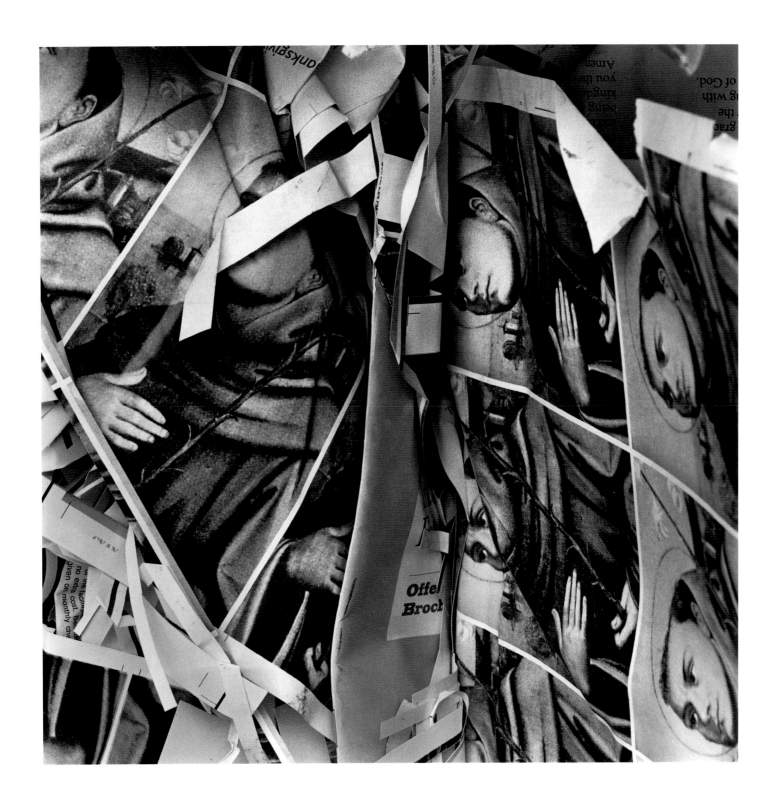

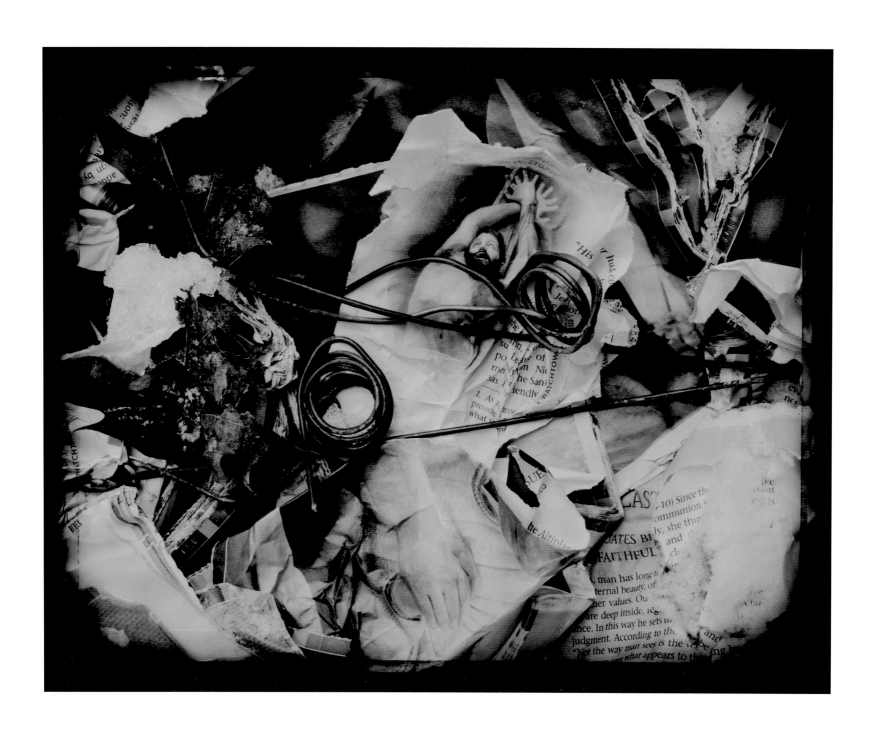

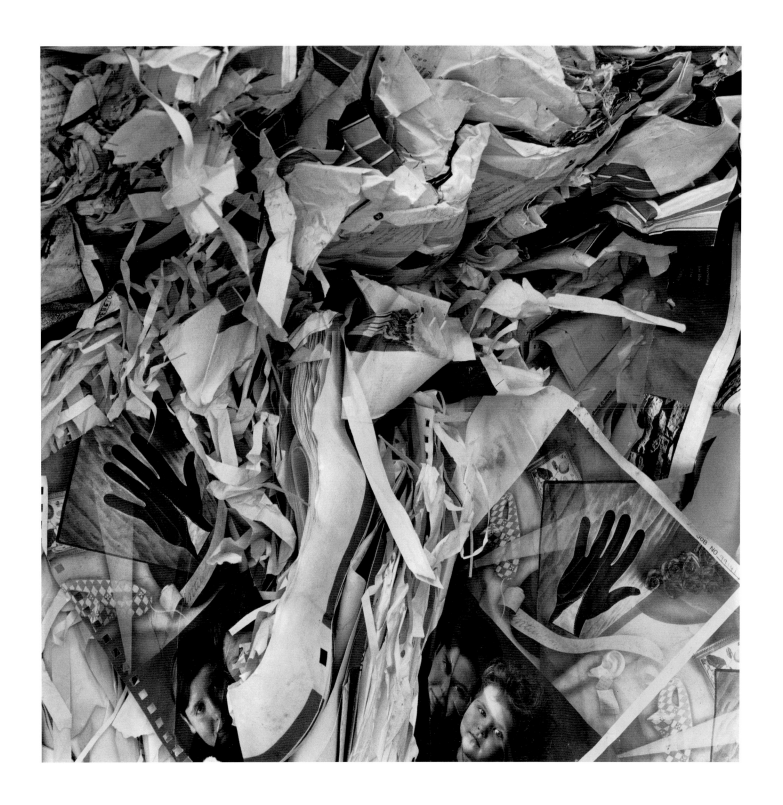

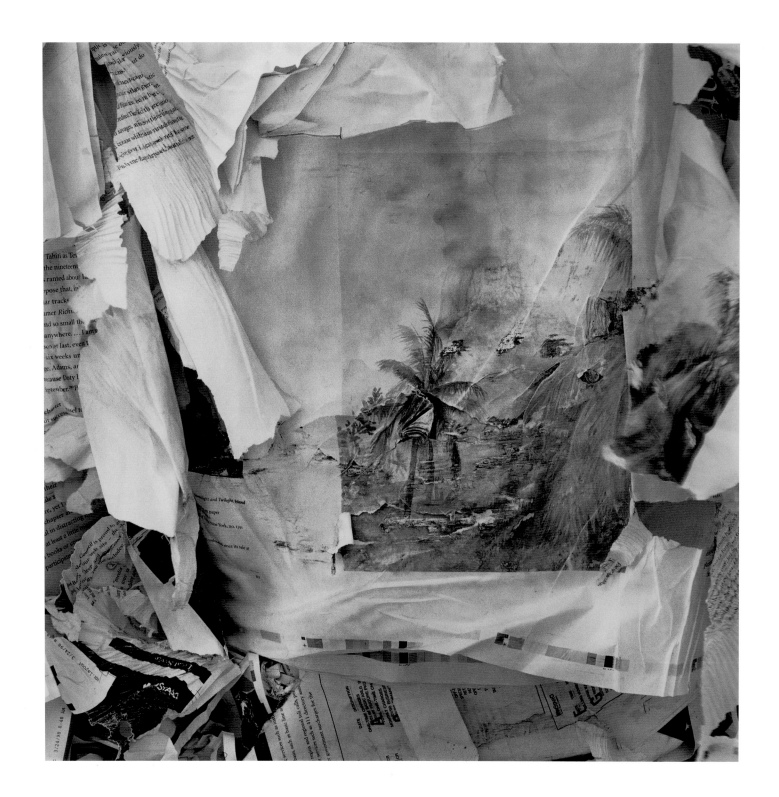

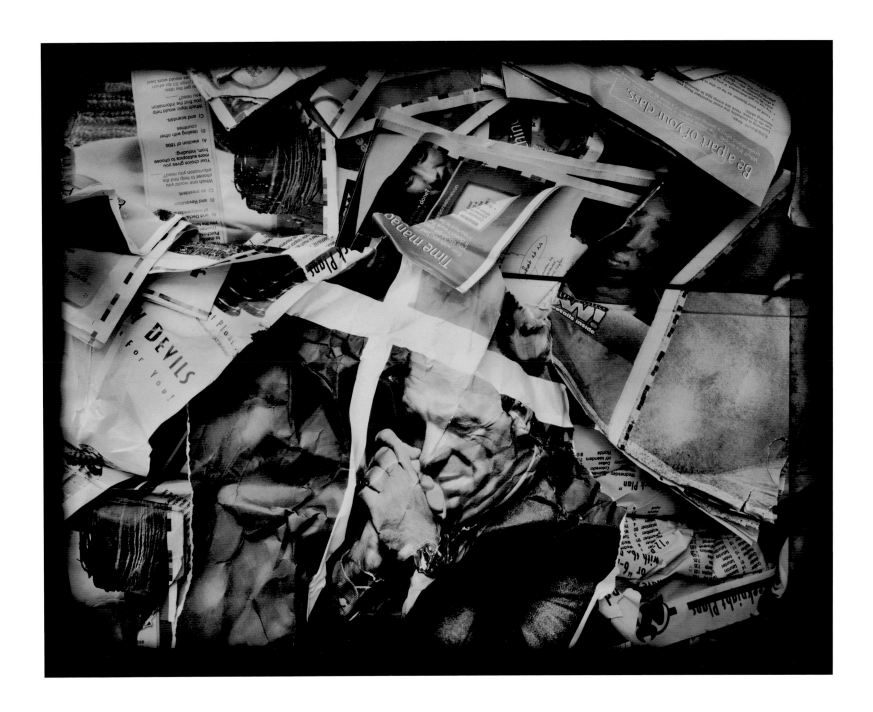

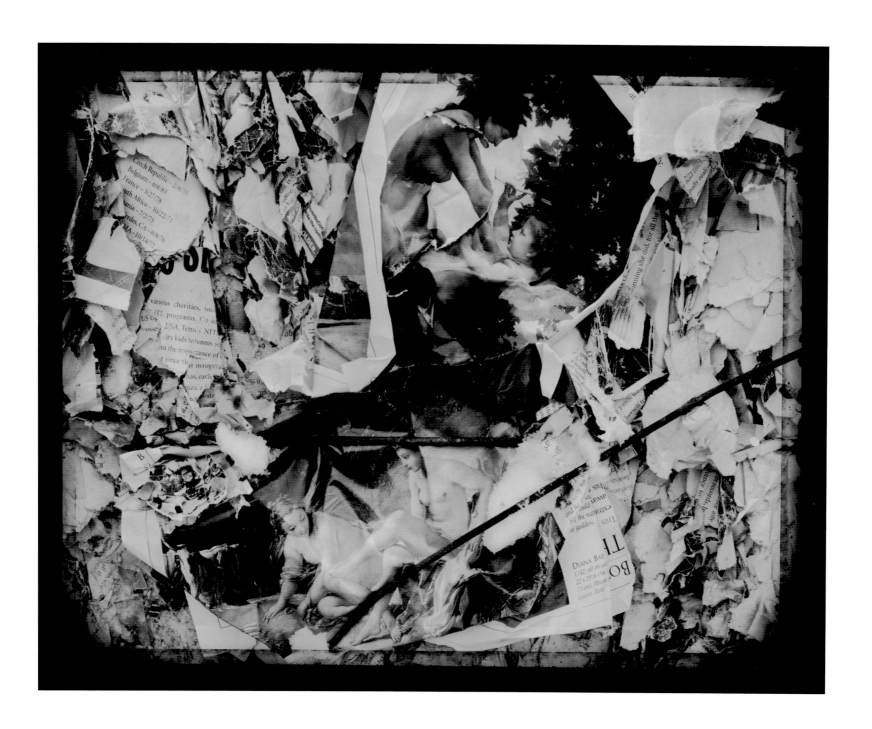

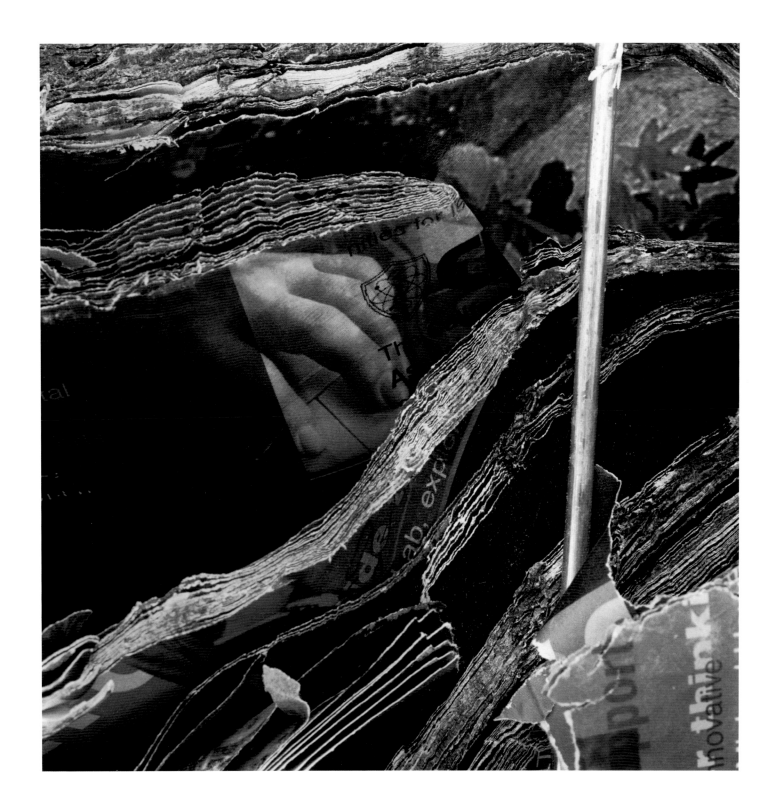

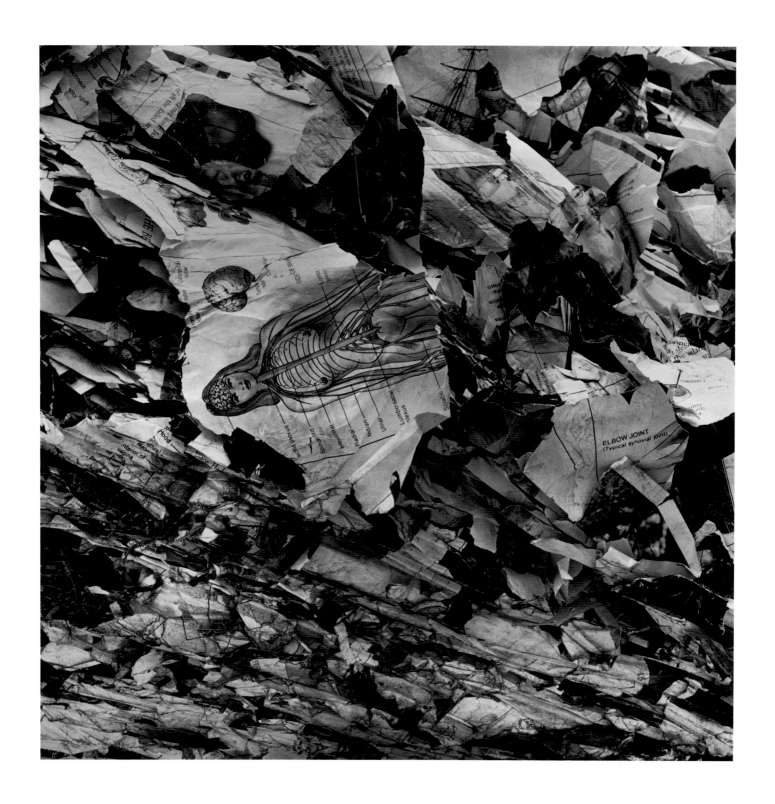

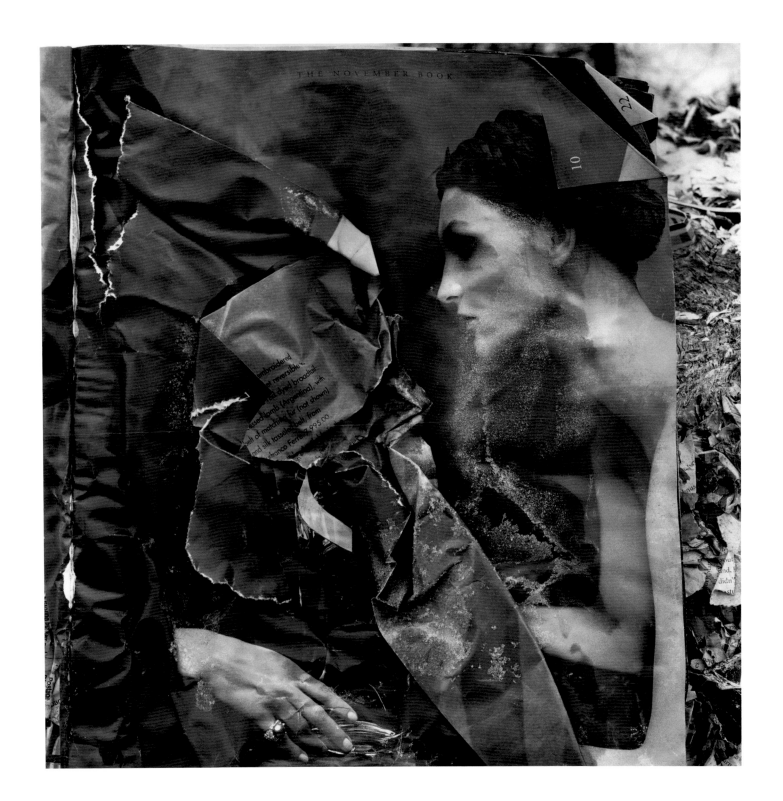

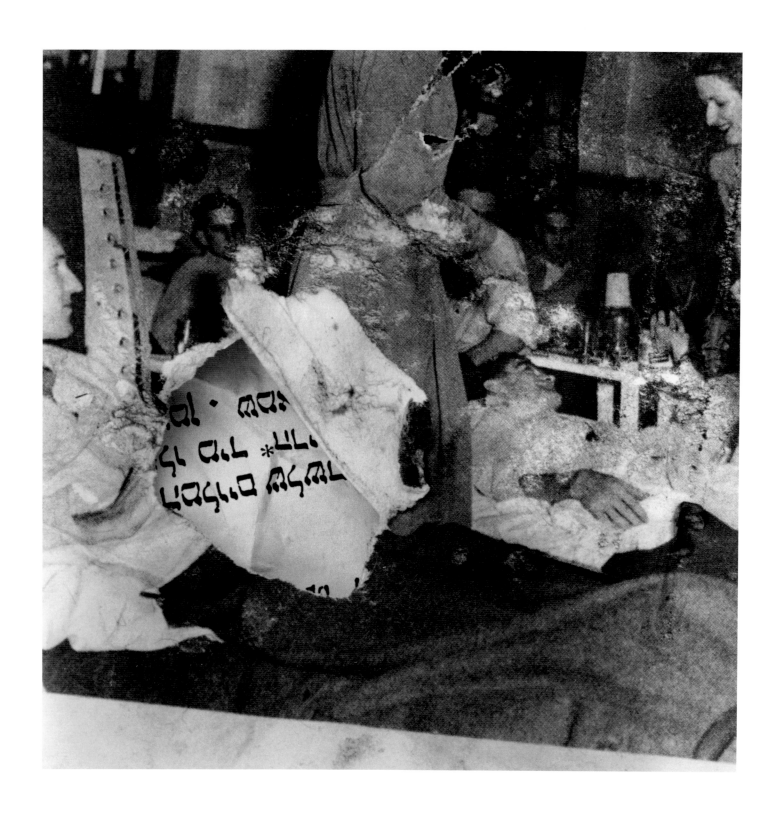

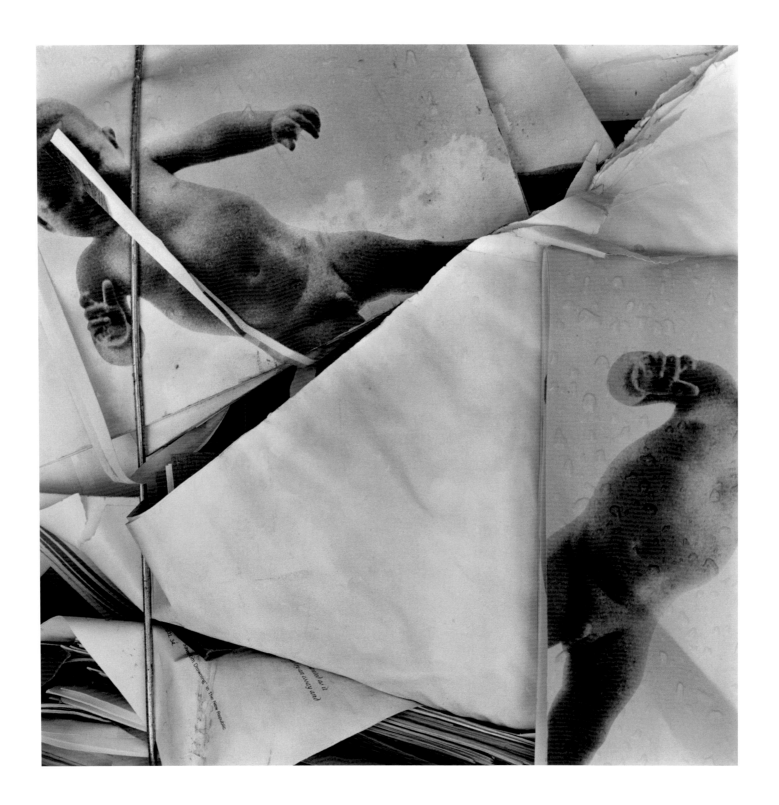

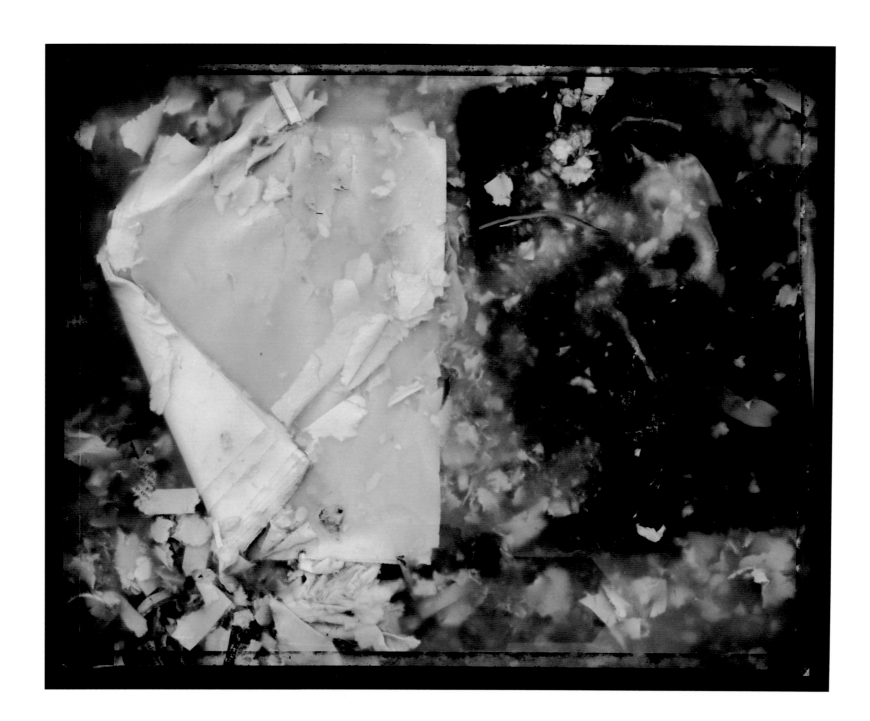

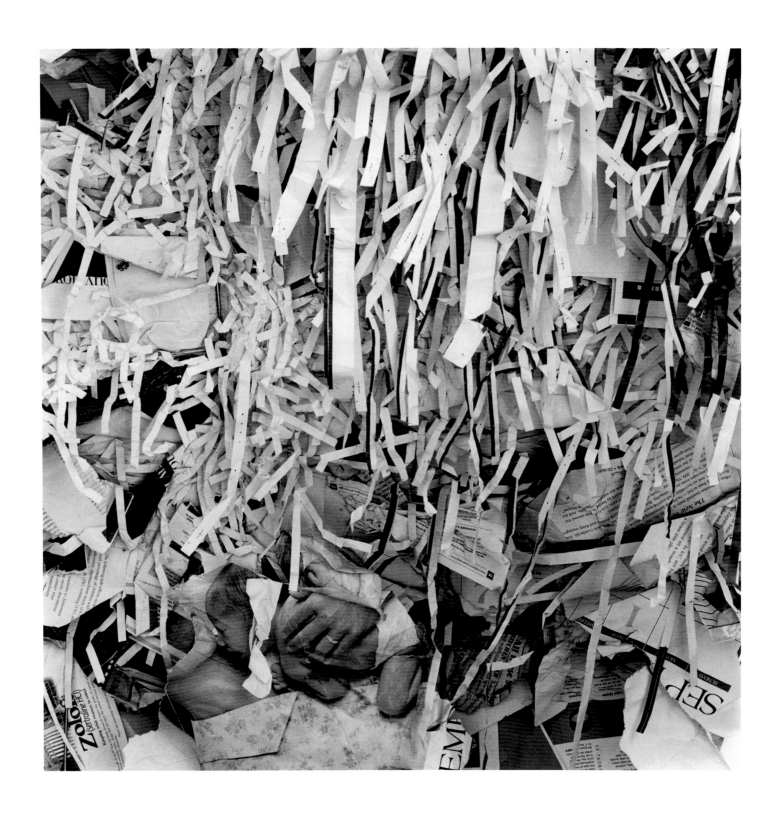

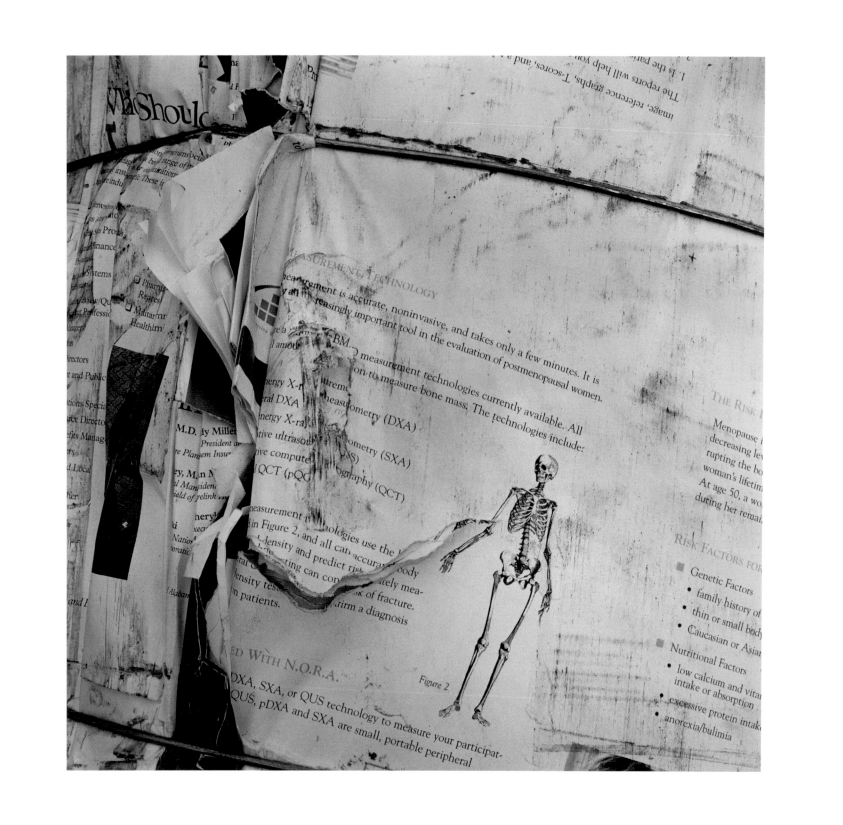

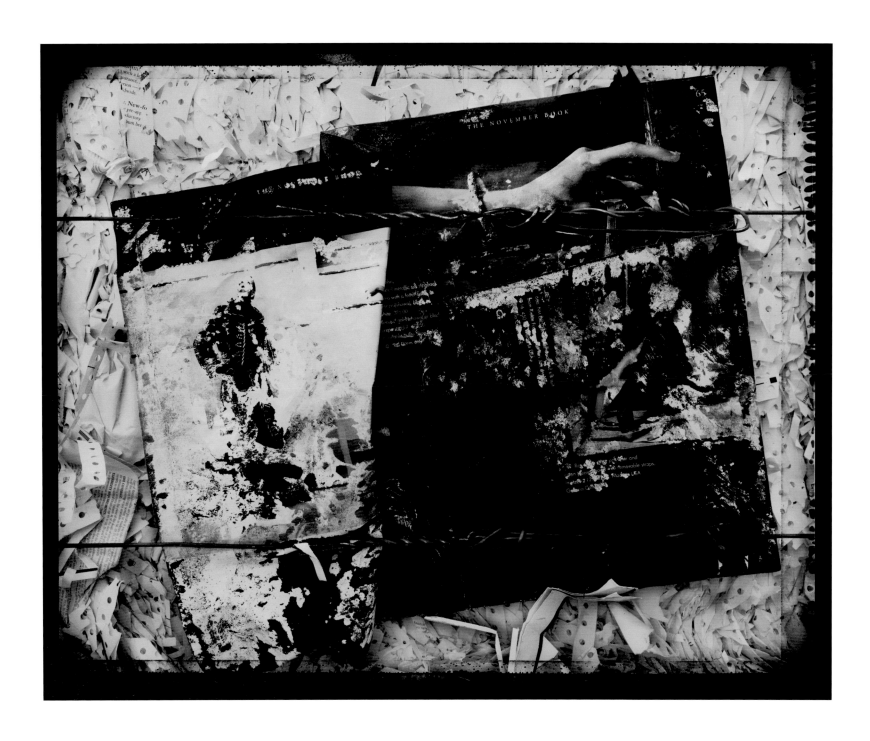

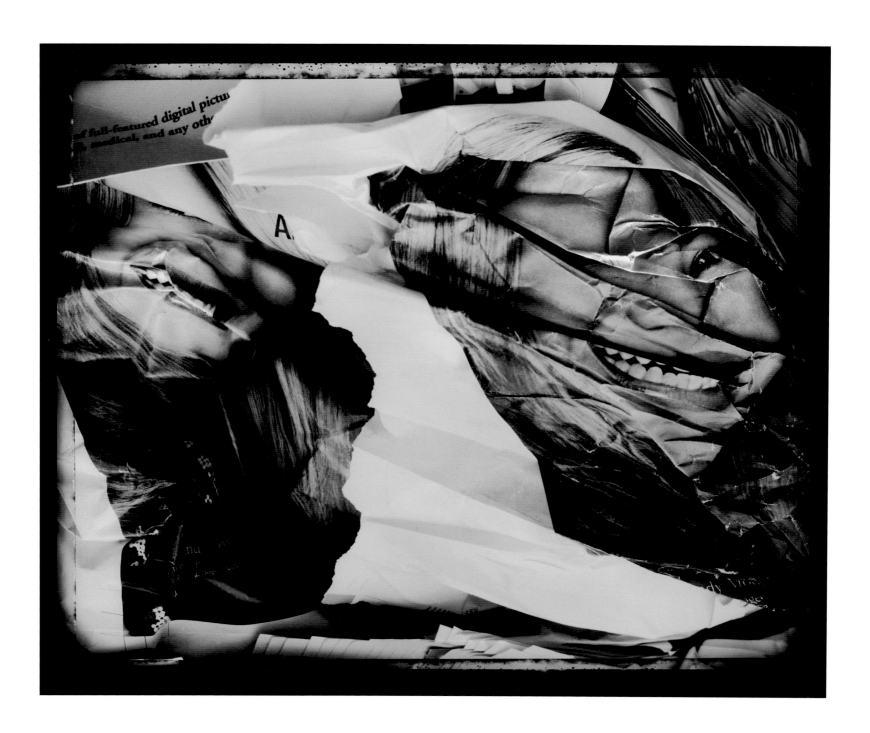

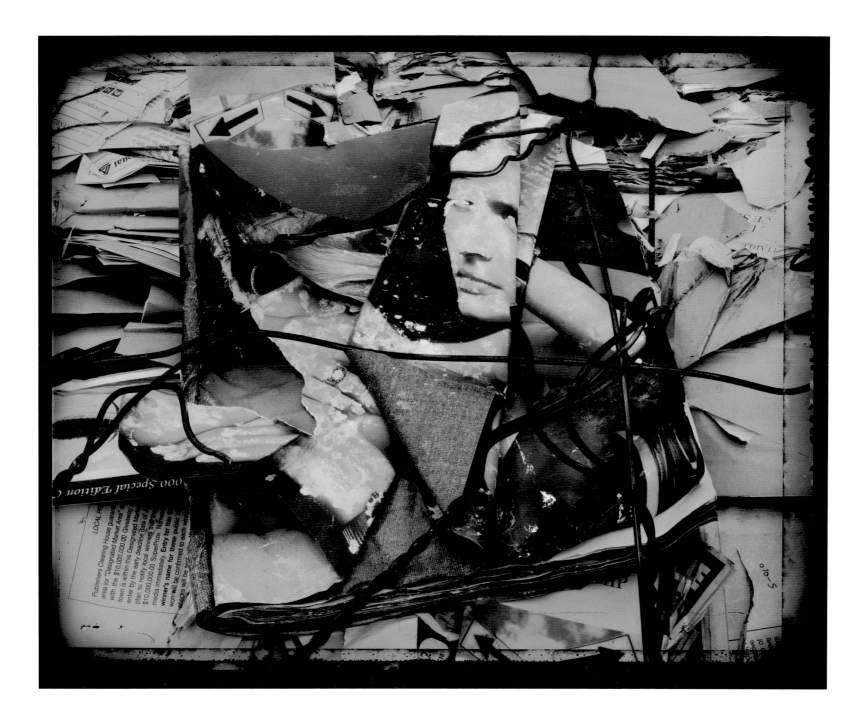

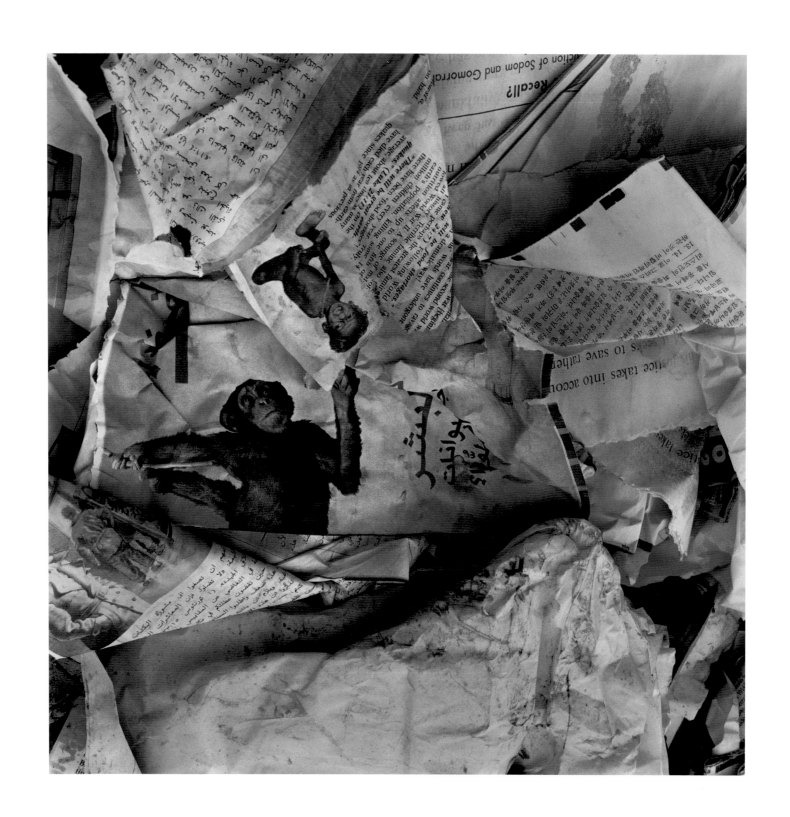

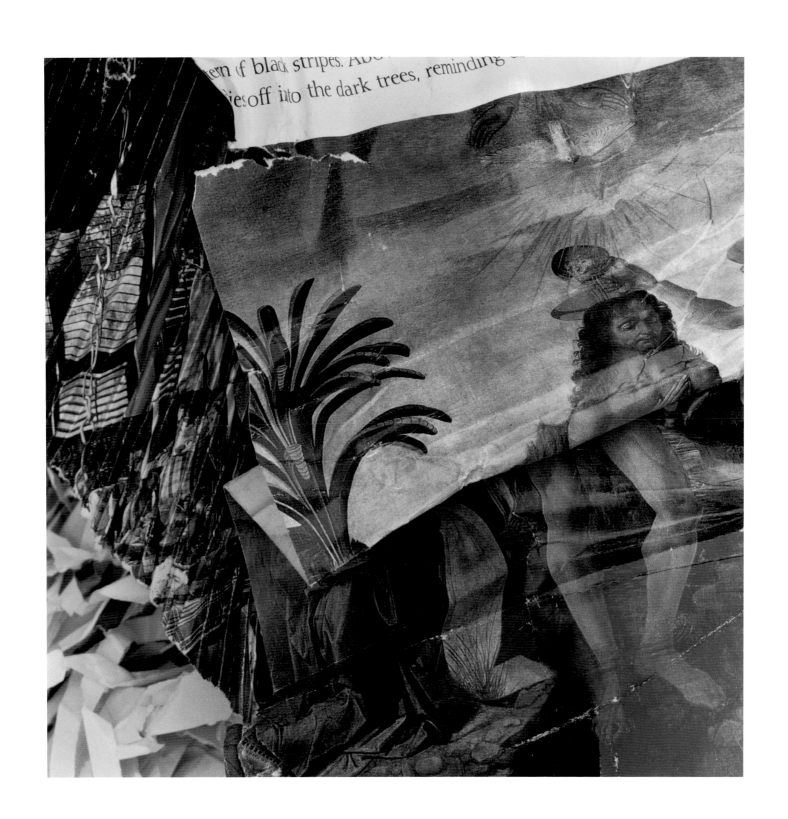

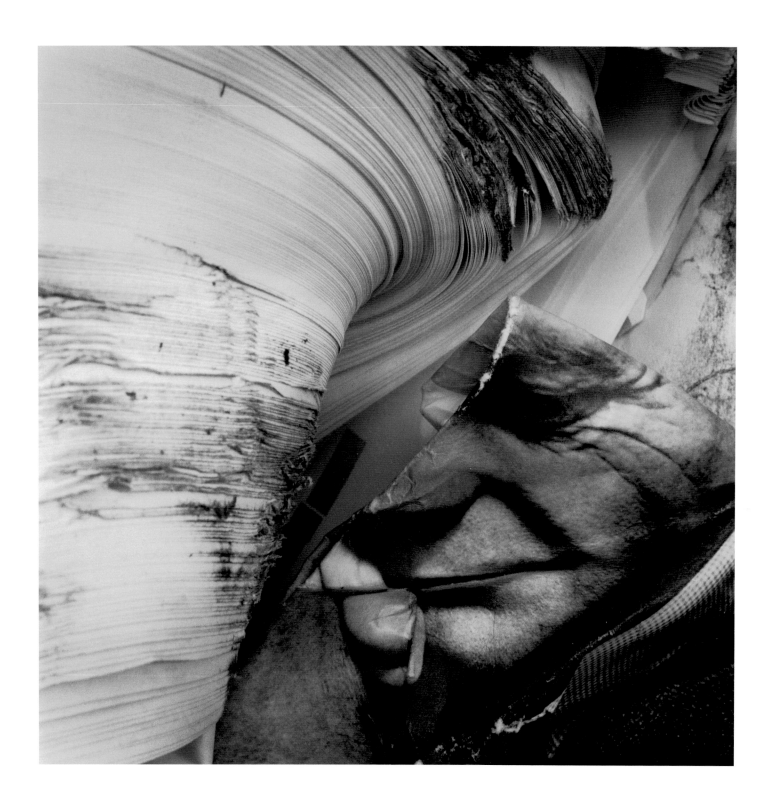

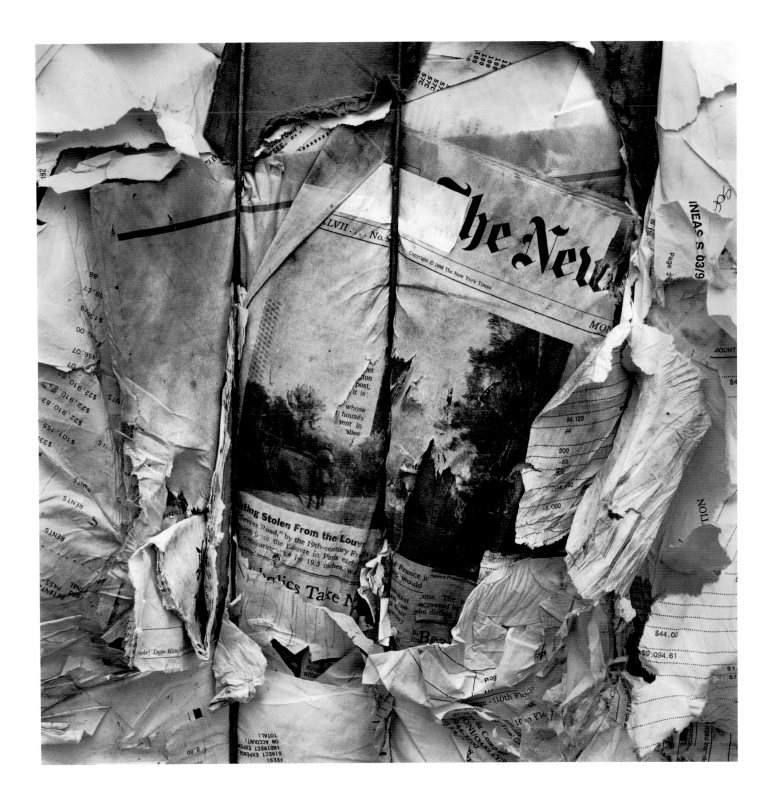

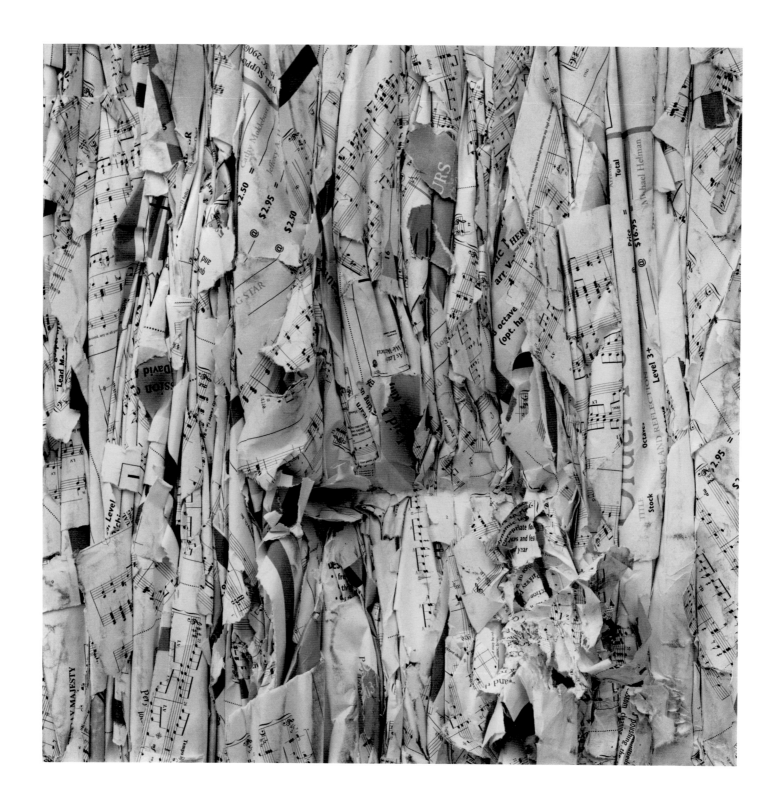

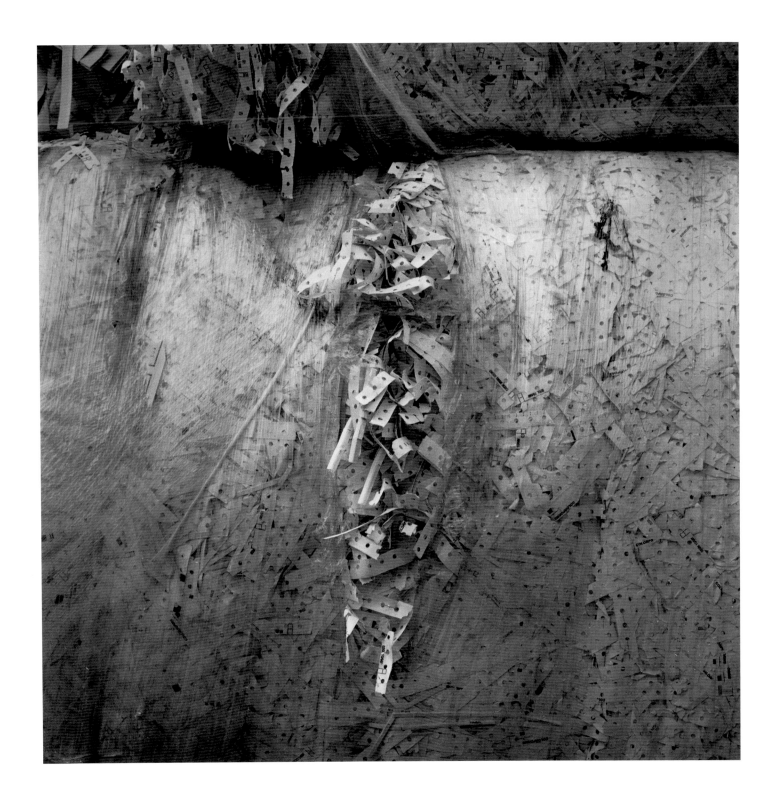

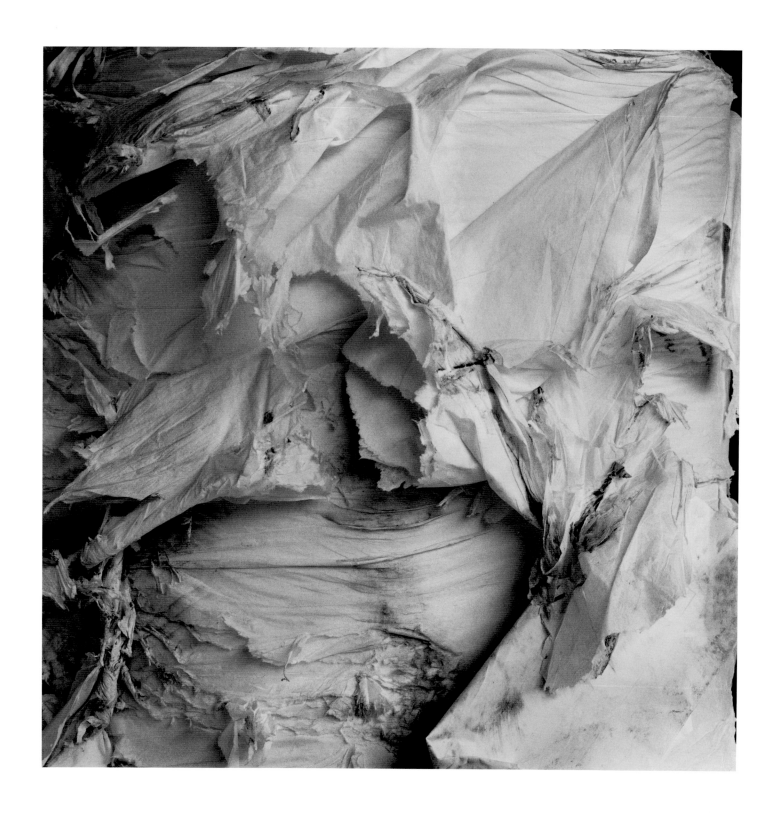

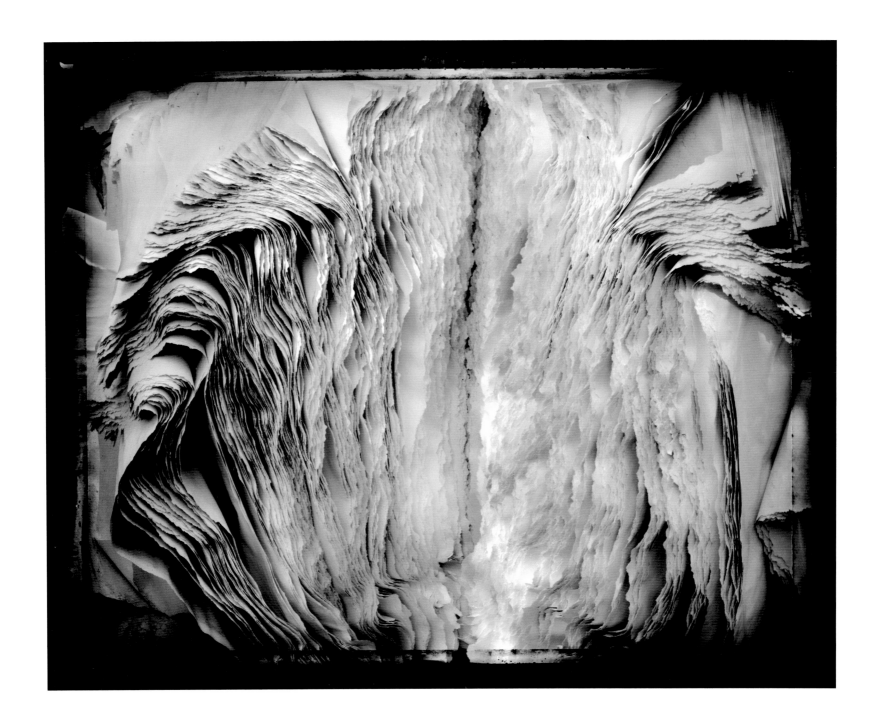

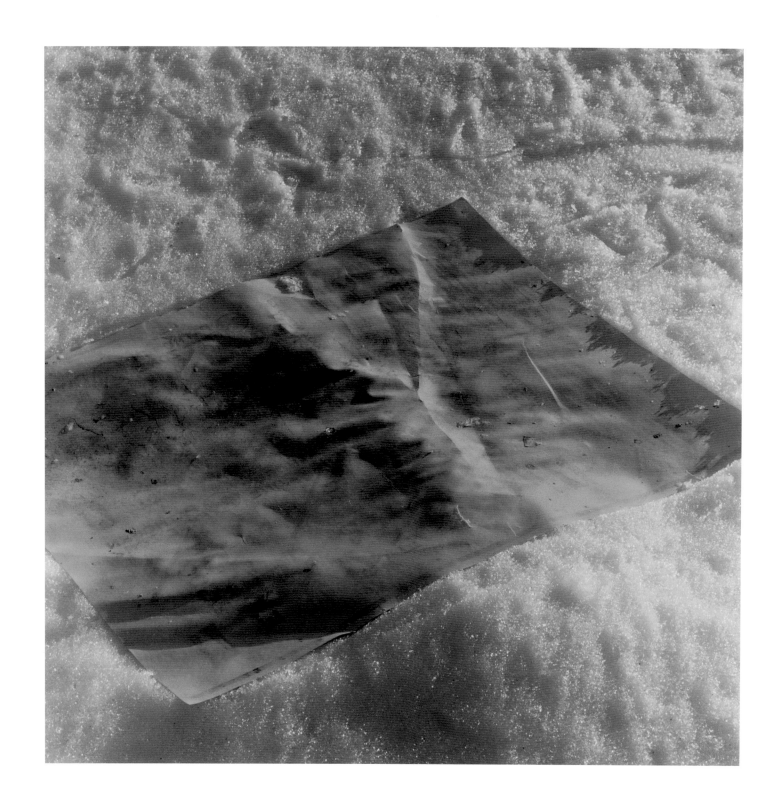

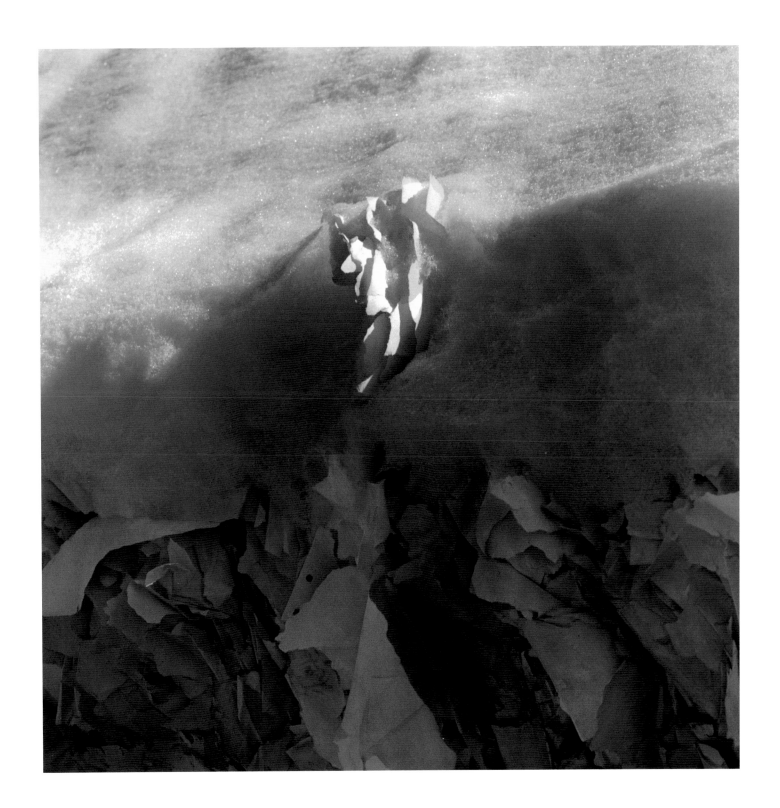

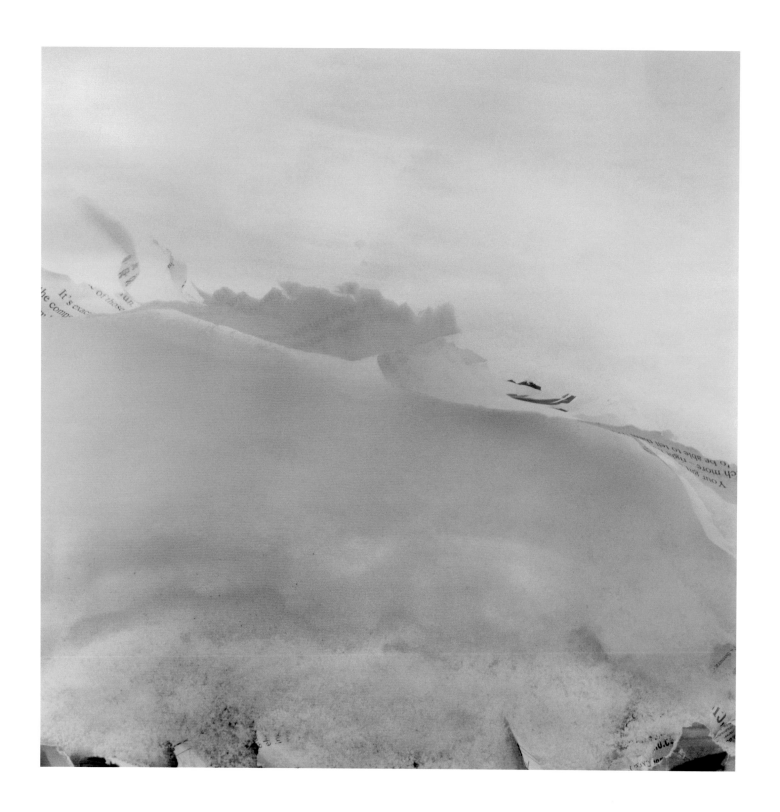

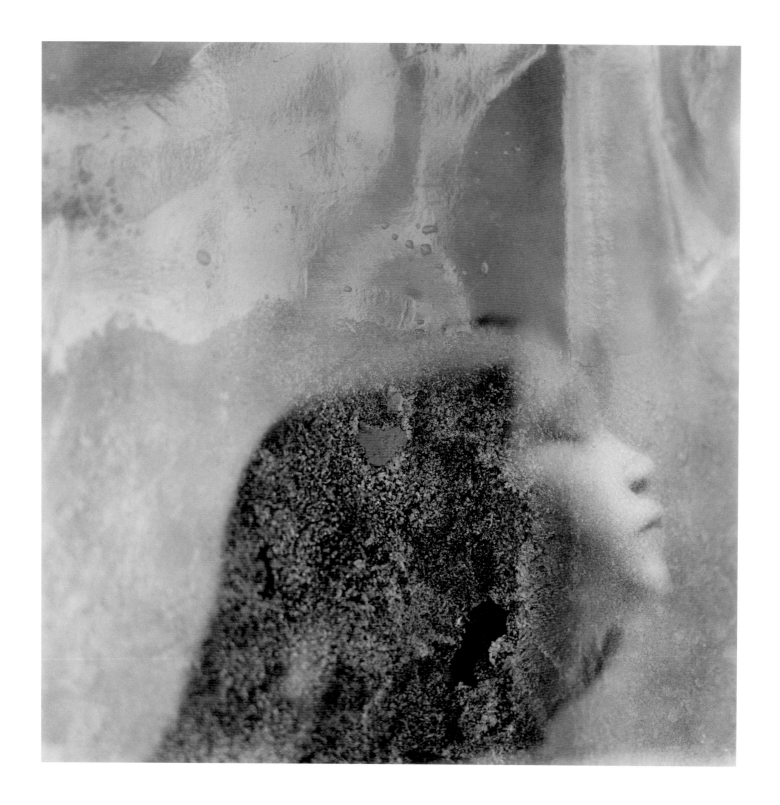

Conclusion: Recycled Realities

Martha A. Sandweiss

PHOTOGRAPHY HAS ALWAYS had the power to make strange the familiar, to make familiar the strange. And so it does in these evocative images by John Willis and Tom Young that document the bales of paper stacked high around a paper mill in western Massachusetts. The luminescent and ethereal stillness of their photographs belies the fact that the pictures were made in an industrial environment, tucked hard between a road, a river, and a railroad track, where the senses are assaulted by the warm, moist smell of steam pouring from the mill, the loud rumble of forklifts shuttling the tightly baled mountains of paper, the gentle slap of loose scraps that swirl up in the wind to hit one on the side of the face. Labor and work, like noise and smell, are rendered invisible here, as Willis and Young turn from the mill itself to focus on the mounds of paper that stand, like bales of hay, in the yard outside the plant. Under the gaze of their cameras, the bales of paper—most discarded from printing plants, some gathered from recycling bins—become something other than the raw materials for an industrial process of paper recycling. They come to resemble landscapes and, like landscapes where one can trace the impact of climatic forces or human presence, they hint at larger stories.

Some of the images focus on the architectural forms of the paper bales themselves; others offer close-up views of the torn and worn fragments of recognizable images and scraps

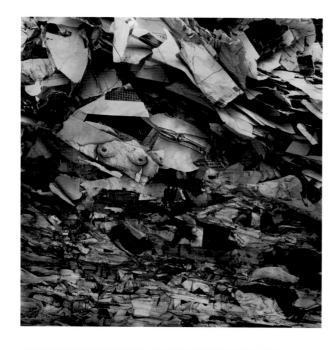

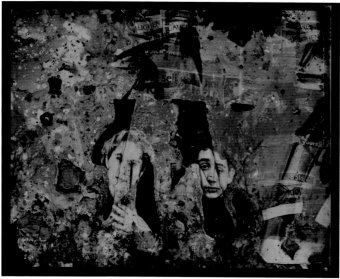

of legible words that emerge from the piles like ancient pottery shards poking up through the ground after a drenching rain, offering to the visual archeologist a wealth of material for analysis and understanding. There are fragments of religious paintings, Civil War *cartes de visite*, unsettling pictures of disembodied babies, images of body parts, texts from business journals, bits of advertisements, pictures that seem ripped from some carelessly discarded family album. There is the familiar face of Iron Eyes Cody, the self-proclaimed Indian whose glycerine tear–streaked face became a symbol of the American environmentalist movement of the 1970s, lying next to a promotion for Chunky Soup. What is one to make of the culture that produced all of this? Saints and sinners alike inhabit this trash heap of history.

There is something violent about these piles of images. Family pictures strewn on the ground, torn photographs of human bodies, dozens of seemingly human eyeballs wrenched from their sockets; these things evoke stories of trauma and physical hurt. They're in the wrong place. Like the ripped pictures of religious figures that emerge from the paper piles in other images, they beg to be handled more tenderly. They belong in family albums, in hushed medical facilities, in the awesome quiet of a church. But then we realize these are not the real things, not actual family snapshots or Civil War portraits or photographs of babies. These are already copies of the real, little more than mass-produced reproductions of things. Some are pages from magazines or newspapers, others are sheets torn from the printing press and discarded because the printing was not quite right. It is slightly unnerving to see multiple copies of the same saint or plaintive child's face staring up from a pile of detritus. But the multiplicity is simply a function of the printing process itself, in which a sheet of paper might be printed with multiple copies of the same image before it is cut or folded for other purposes. Thus, even as the images evoke a sense of violence, they narrate a tale of mass consumption and consumer waste. We've not only invented all these strange stories, we've thrown them away.

Some of the close-up views of these paper shards of our civilization are more abstract and even disorienting for their lack of a clear sense of scale. The swirling whorls of closely stacked sheets of paper can evoke a layered rock or the symmetrical rings of a tree trunk. Paper comes from tree products, of course, but it seems odd to see such natural forms

echoed in these piles that are the product of a market economy and a highly mechanized printing industry. A few of the images evoke Edward Weston's celebrated photographic close-ups of vegetables; an elegant beauty emerges where we'd least expect it, as the photograph confers upon a commonplace object a monumentality that suddenly commands our attention. In other pictures, bundled waste paper suddenly looks like a weathered stone formation or, when covered in snow, like a mountain range of indeterminate scale and reach.

The illusion that we are looking at strangely familiar and unfamiliar landscapes is most acute in the pictures that frame a more distant view of the paper bales. The hard cement and asphalt lot outside the mill sometimes seems a freshly mowed field, the stacks of paper sweet-smelling hay that sway and dance in animate fashion under a big sky. Waste thus seems not so much a blight on the landscape as an integral and harmonious part of it. And those stacks of paper that can evoke grassy groves or neatly baled farm products or the wind-carved buttes of some Western landscape come to seem almost beautiful, because they correspond so perfectly with the sorts of vistas to which we conventionally assign a judgment of aesthetic grace or virtue. With all evidence of the human labor that produced these piles of paper waste erased, the vistas come to seem "natural," as if they simply, always, just were.

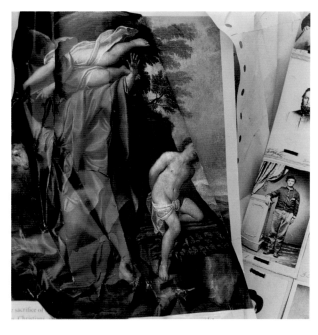

The photographers thus compel the viewer to stop and wonder about their larger political and aesthetic ambitions for this work. Are the photographs meant to be a sort of polemic on the wastefulness of our culture? A reminder that beauty can be found even in the most improbable of places? An ironic look at how the mass media has helped to create and sustain a consumer culture? The ambiguity of the message adds to the pleasure one experiences in looking at these pictures.

Ultimately, Willis and Young are like archeologists, patiently staking out unfamiliar ground for us and then moving in close to catalogue what they find. The rows of lithesome paper bales, the scraps of printed pages—these things seem to tell the story of some odd civilization. But the photographers wisely refrain from preaching, from becoming archeologists who would chart all the shards and create some sort of careful chronological timeline of the culture that could produce such rich trash heaps of waste. In the end, they leave the

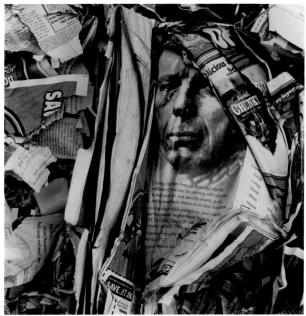

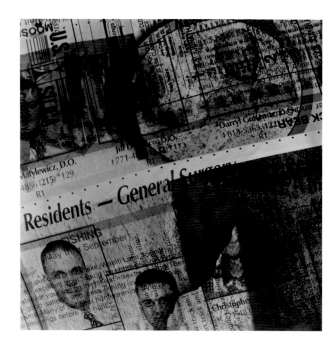

storytelling and interpretation to us. In compelling us to look closely at what we have discarded, they invite us to become our own archeologists, to pause and consider just who we are. And they force us to stop dead in our tracks and wonder in astonishment that in piles of paper we could discover such beauty.

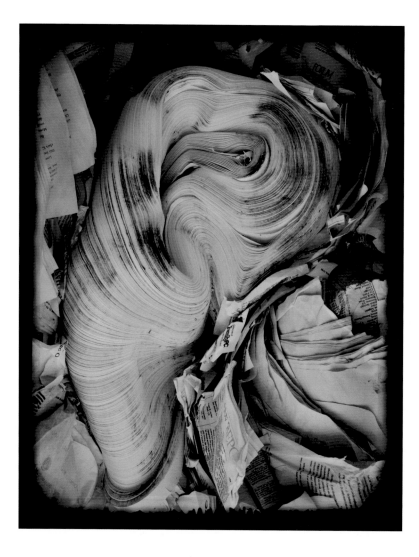

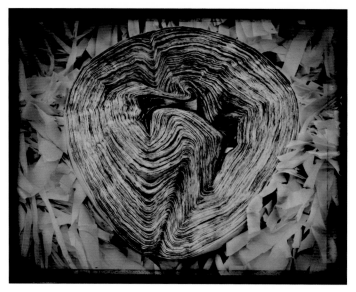

Acknowledgments

WE WISH TO EXPRESS OUR GRATITUDE and appreciation to everyone who has encouraged us in the process of making this book.

The following donors generously contributed to the funding of this project: Lillian Farber, Charles Housen, Marlboro College, Thomas Newton, Jeanne and Richard S. Press, and David Willis. The work was also generously funded in part by Individual Artists Fellowships from the Vermont Arts Council, the Massachusetts Cultural Council, and the Vermont Council on the Arts Endowment Fund.

We are grateful to the network of people who donated their time and wisdom to various aspects of the production of this book, including George F. Thompson, Bob Thall, the respective staffs at the Center for American Places and at Columbia College Chicago, Martha A. Sandweiss, Sylvia Wolf, Phyllis Menken, Justin Kimball, Deborah Kao, Emmet Gowin, and Carl Chiarenza. We appreciate the opportunity and kindness given to us by the administration and employees of the Erving Paper Mill in Erving, Massachusetts, who allowed us to photograph over the years. And a very special thanks for the encouragement, unwavering support, and inspiration of our respective families, including Paulene, Elijah, Meta, Alan, Susannah, Sarah, and Rosey.

Finally we express appreciation to the general public which has made, and continues to make, the effort to recycle its paper products.

About the Authors and the Essayist

JOHN WILLIS was born in 1957 in Stamford, Connecticut. He received his M.F.A. in photography from the Rhode Island School of Design in 1986. He is currently a professor at Marlboro College and co-founder of the In-Sight Photography Project and the Exposures cross-cultural youth photography program, which offers courses to southern Vermont's youth, regardless of their ability to pay. He has been awarded five Artist Fellowships from the Vermont Council on the Arts and two from the Vermont Arts Endowment Fund. His work is included in numerous permanent collections, including the Whitney Museum of American Art, Museum of Fine Arts in Boston, and Museum of Fine Arts in Houston. His photographic work has been exhibited nationally and internationally, and it has appeared in various publications, including *LensWork*, *Orion* magazine, and *Flesh and Blood, Photographers Photograph Their Families* published by *The Picture Project*. He resides in Dummerston, Vermont.

TOM YOUNG was born in 1951 in Boston, Massachusetts. He received his M.F.A. in photography from the Rhode Island School of Design in 1977. He is currently a professor of art at Greenfield Community College in Greenfield, Massachusetts. He has been awarded an Artist Fellowship from the National Endowment for the Arts and four Artist Fellowships from the Massachusetts Cultural Council. His work is included in numerous permanent collections, including the Museum of Fine Arts in Boston, Polaroid International Collection in Offenbach, Germany, and Harvard University's Fogg Museum. Young's work has been exhibited internationally, including the International Center of Photography in New York City, the Frans Hals Museum in Harlem, The Netherlands, the Kunsthalle in Hamburg, Germany, and the National Museum of Fine Arts at the Smithsonian Institution in Washington, D.C. His photographs have appeared in a number of publications, including *Artworks: Tom Young* (Williams College Museum of Art), *American Perspectives* (Tokyo Museum of Photography), *Goodbye to Apple Pie* (DeCordova Museum, Lincoln, Massachusetts), and *2 to Tango: Collaboration in Recent American Photography* (International Center of Photography). He resides in Buckland, Massachusetts.

MARTHA A. SANDWEISS is a professor of American studies and history at Amherst College. Previously she was the curator of photographs at the Amon Carter Museum in Fort Worth, Texas. She is the author of *Print the Legend: Photography in the American West* (Yale, 2002) and *Laura Gilpin: An Enduring Grace* (Amon Carter Museum, 1986), co-author of *Eyewitness to War: Prints and Daguerreotypes of the Mexican War, 1846–1848* (Smithsonian Institution Press, 1989), editor of *Photography in Nineteenth-Century America* (Abrams, 1991), and co-editor of *The Oxford History of the American West* (Oxford, 1994).

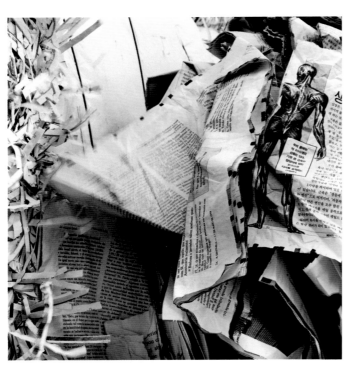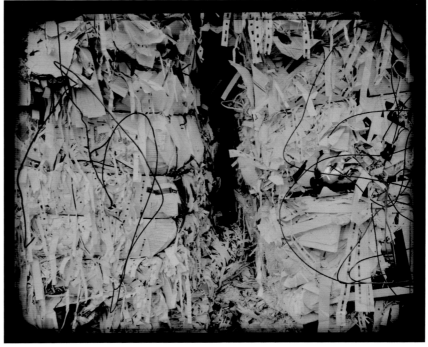

The Center for American Places is a tax-exempt 501(c)(3) nonprofit organization, founded in 1990, whose educational mission is to enhance the public's understanding of, appreciation for, and affection for the natural and built environment. Underpinning this mission is the belief that books provide an indispensable foundation for comprehending and caring for the places where we live, work, and explore. Books live. Books endure. Books make a difference. Books are gifts to civilization.

With offices in Santa Fe, New Mexico, and Staunton, Virginia, Center editors bring to publication as many as thirty books per year under the Center's own imprint or in association with publishing partners. The Center is also engaged in numerous other programs that emphasize the interpretation of place through art, literature, scholarship, exhibitions, and field research. The Center's Cotton Mather Library in Arthur, Nebraska, its Martha A. Strawn Photographic Library in Davidson, North Carolina, and a ten-acre reserve along the Santa Fe River in Florida are available as retreats upon request. The Center is also affiliated with the Rocky Mountain Land Library in Colorado.

The Center strives every day to make a difference through books, research, and education. For more information, please send inquiries to P.O. Box 23225, Santa Fe, NM 87502, U.S.A., or visit the Center's Website (www.americanplaces.org).

ABOUT THE BOOK:
The text for *Recycled Realities* was set in Univers with Memphis display. The paper is acid-free Silk Gallery, 170 gsm weight. The four-color separations, printing, and binding were professionally rendered by Oddi Printing Ltd., of Reykjavik, Iceland. The photographs in this book by John Willis are medium format and square; Tom Young's large format images are rectangular. Willis's original prints are selectively bleached and toned gelatin silver prints; Young's are tri-tone pigmented ink prints. *Recycled Realities* was published in association with the Photography Department at Columbia College Chicago, which is one of the nation's largest and most prestigious photography programs. For more information, visit online at: www.colum.edu/undergraduate/photo.

FOR THE CENTER FOR AMERICAN PLACES:
George F. Thompson, President and Publisher
Randall B. Jones, Independent Editor
Amber K. Lautigar, Publishing Liaison and Associate Editor
Rebecca A. Marks, Production and Publicity Assistant
David Skolkin, Book Designer and Art Director

FOR COLUMBIA COLLEGE CHICAGO:
Christine DiThomas, Manuscript Editor
Mary Johnson, Director of Creative and Printing Services
Benjamin Gest, Director of Digital Scans
Tammy Mercure, Digital Imaging Facilities Coordinator
Thomas Shirley, Coordinator of Digital Imaging
Bob Thall, Chairman, Photography Department